2001

2001

Visions *of* Adventure

N. C. WYETH AND THE BRANDYWINE ARTISTS

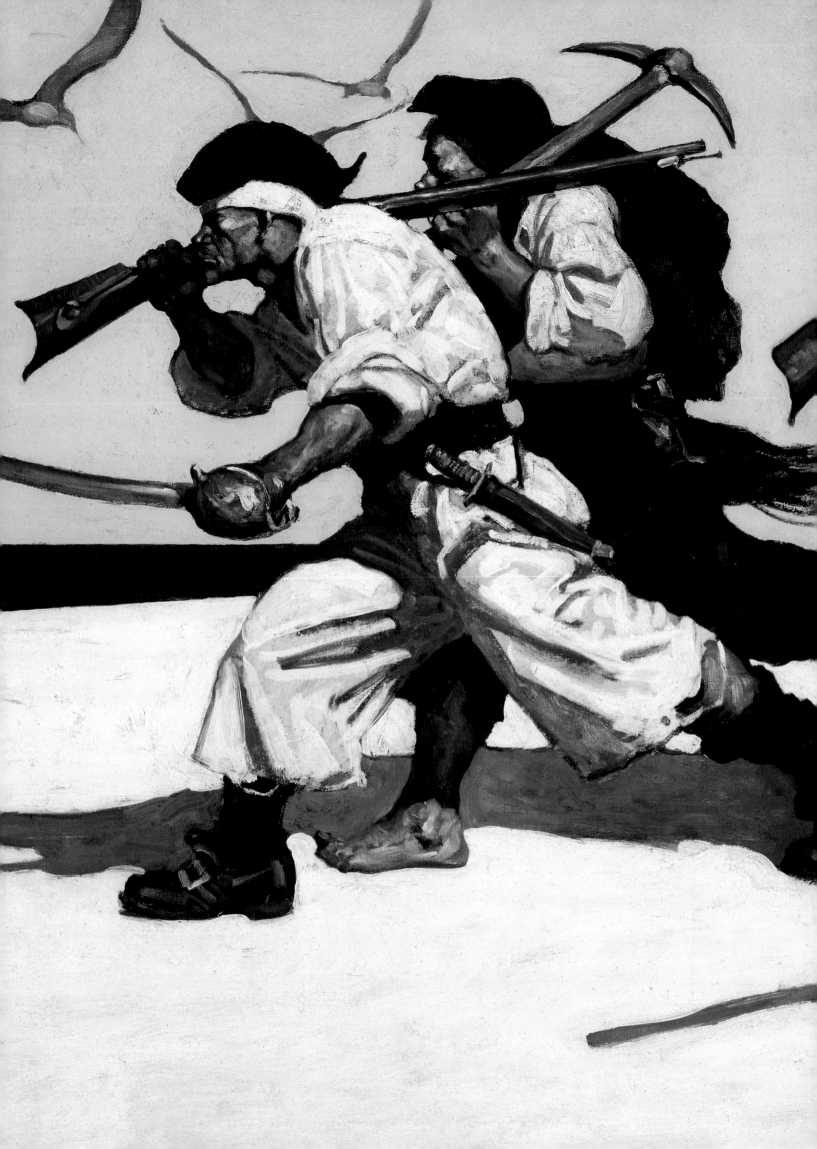

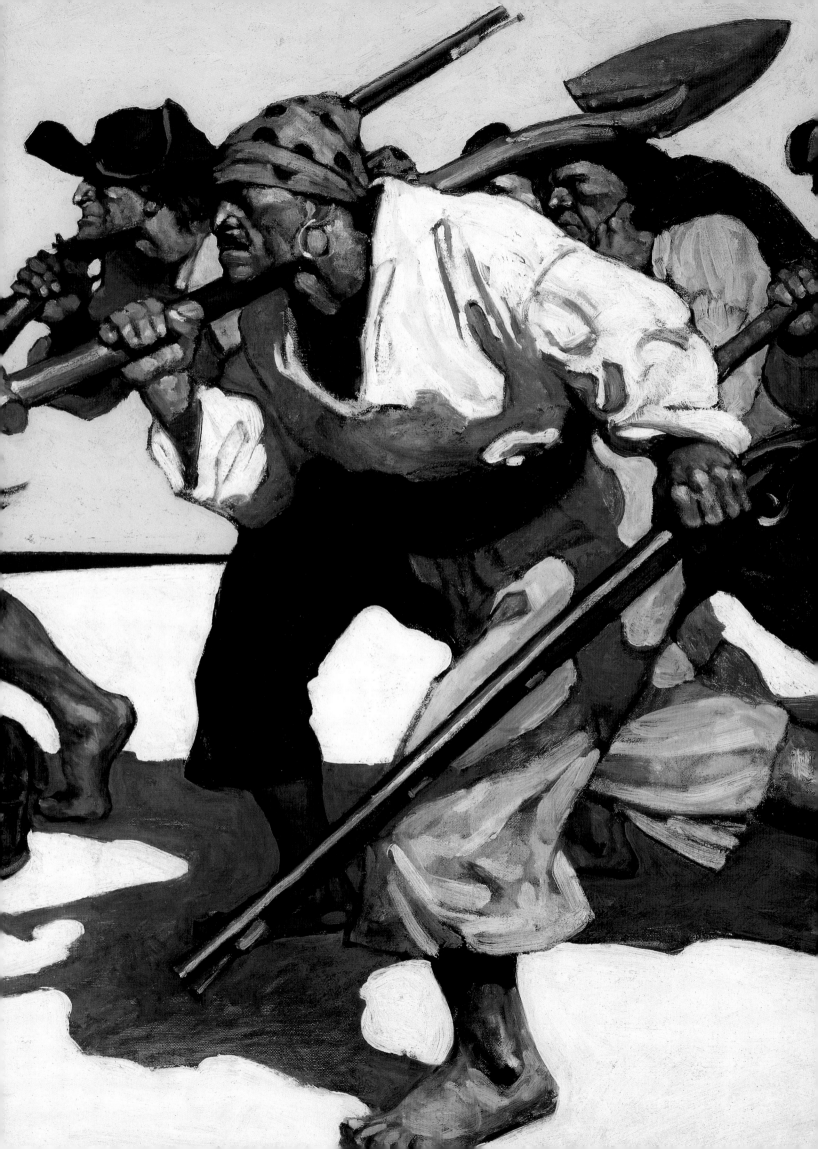

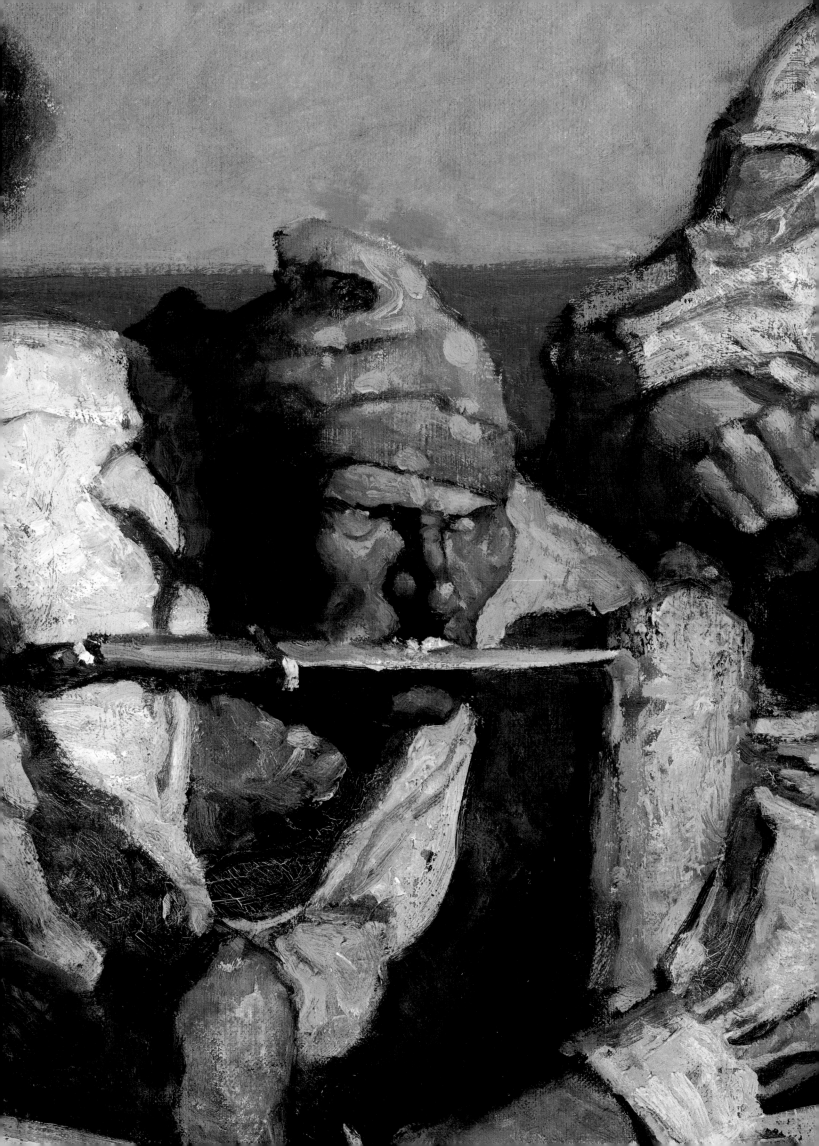

Visions *of* Adventure

N. C. WYETH AND THE BRANDYWINE ARTISTS

A COLLECTION OF PAINTINGS BY
Howard Pyle
N. C. Wyeth
Harvey Dunn
Frank E. Schoonover
Philip R. Goodwin
Dean Cornwell

EDITED BY
John Edward Dell
in association with Walt Reed

ESSAYS BY
Douglas Allen Jr.
John Apgar
John Edward Dell
Chris Fauver
Michael Frost
Elizabeth Hawkes
Victoria Manning
Roger Reed
Walt Reed
Sadie Somerville

WATSON-GUPTILL PUBLICATIONS
New York, N.Y.

Paintings photographed by Steve Saltzman with three exceptions as noted.

Acknowledgments:
Mr. John Schoonover, interview November 1994.
Mrs. Betsy Wyeth, curator of the N. C. Wyeth Estate, for permission to cite published letters of N. C. Wyeth.

Pages 2–3: N. C. Wyeth, Detail from endpapers illustration from *Treasure Island,* see page 41.
Page 4: N. C. Wyeth, Detail from illustration from *Treasure Island,* see page 45.

Senior Editor: Candace Raney
Editor: Margaret Sobel
Design: Eric Baker Design Associates
Production Manager: Hector Campbell
Text set in 12-point HTF Fell Historical

First published in 2000 in the United States
by Watson-Guptill Publications,
a division of BPI Communications, Inc.,
1515 Broadway, New York, N.Y. 10036

Library of Congress Cataloging-In-Publication Data
Visions of adventure: N. C. Wyeth and the Brandywine artists / edited by John Edward Dell
in association with Walt Reed; essays by Douglas Allen . . . [et al].
p. cm.
"A collection of paintings by Howard Pyle, N. C. Wyeth, Harvey Dunn, Frank Schoonover,
Philip R. Goodwin, Dean Cornwell."
Includes bibliographical references and index.
ISBN 0-8230-5608-2
1. Painting, American. 2. Painting, Modern—20th century—United States.
3. Illustration of books—20th century—United States. 4. Adventure stories—Illustrations.
I. Dell, John Edward. II. Reed, Walt.
N6512.V57 2000
759.13—dc21 00-023010

Printed in Italy

First printing, 2000

1 2 3 4 5 6 7 8 9 / 06 05 04 03 02 01 00

EDITOR'S NOTE

John Edward Dell created this collection as a personal project in the 1990s and it was the genesis of this book.

All of the pictures included in this volume were originally in that collection with the exception of the plates on pages 37, 104, and 107, which have been inserted to supplement the story sequence. Several of the pictures have since been dispersed to other collections.

W. R.

Contents

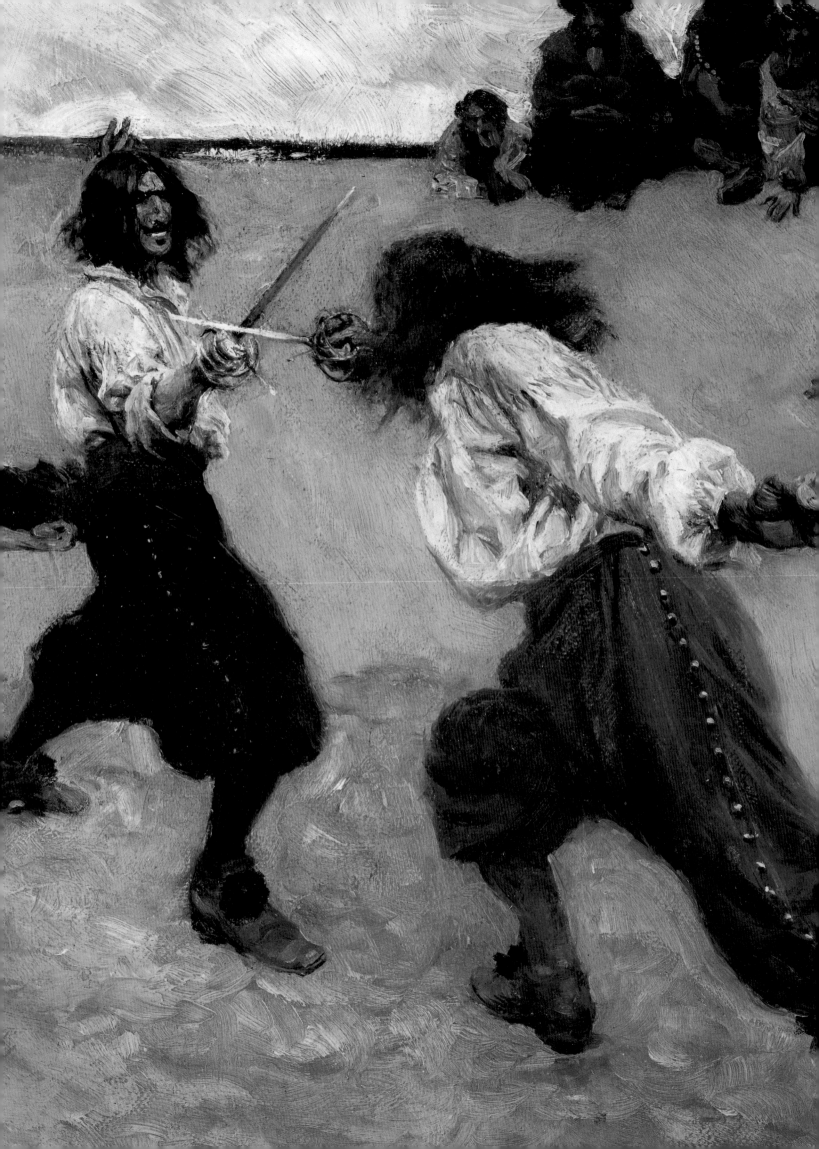

Introduction

LET'S LEAVE BEHIND the television and the VCR for a while and turn instead to colorful pages from books and magazines of a century or less ago. Our quest is to rediscover popular adventure tales. We'll look at adventurers of an earlier era: Sir Launcelot and Orlando, buccaneers and cowboys, hunters and outlaws. For readers curled up in comfortable chairs, reading by kerosene lamps, these are the pictures accompanying stories that raised the hair on the backs of their necks or brought sympathetic tears to their eyes.

At the turn of the century, adventure stories by Robert Louis Stevenson, Charles Kingsley, Arthur Conan Doyle, James Branch Cabell, and Howard Pyle provided entertainment for the American public. Vivid pictures in the magazines lured new readers. Historical romance and adventure stories about pirates and the frontier targeted male readers, whether they were young readers of *Youth's Companion* or adult subscribers to *Collier's Weekly* or *The Saturday Evening Post*. Westerns and pirate fiction provided a form of escapism for those weary of the domestic stories that were popular in late-Victorian periodicals.

The collection represented in this book features exceptional adventure subjects by six gifted Brandywine School illustrators: Howard Pyle, N. C. Wyeth, Harvey Dunn, Frank E. Schoonover, Philip R. Goodwin, and Dean Cornwell. It started with Howard Pyle. He taught all of them except Dean Cornwell, a younger man, who learned Pyle's principles secondhand in Harvey Dunn's art classes. Dating from 1899 to the middle of the Depression, these paintings reflect America's delight in self-reliant heroes and villains. Of special interest are the twenty-two works by N. C. Wyeth that span thirty years of his career beginning with "The Moose Call," an early illustration bought for *Scribner's Magazine* in 1904. Pictures abound from the Scribner's Illustrated Classic Series—*Treasure Island*, *The Black Arrow*, *The Boy's King Arthur*, *Westward Ho!*, *The Last of the Mohicans*, and *Drums*. From the stunning success of *Treasure Island* in 1911 to *Drums*, published nearly fifteen years later, these books celebrate Wyeth's preeminent stature as an American illustrator.

Though publishers commissioned most of these paintings to illustrate poems or adventure stories, the works can stand alone. No text is needed to understand the drama of Howard Pyle's "Dead Men Tell No Tales" or the poetry of N. C. Wyeth's "The Magic Pool" and "Summer," scenes that capture man's spiritual bond with nature. In "Rip Van Winkle Awakes" Wyeth turned to the challenge of landscape painting, while Frank Schoonover captured the repose of a Native American in "A Northern Mist." Though the Brandywine illustrators primarily produced work for publication, they also painted landscapes, still lifes, or figure paintings not intended for publication. As a teacher, Pyle believed his role was to produce "painters of pictures," not simply illustrators of books. In his view, experience as an illustrator would benefit a painter.

Howard Pyle was both a storyteller and an artist. Editors coveted a Pyle frontispiece as a sure way to sell magazines. Children enjoyed his books about Robin Hood and King Arthur, while their parents picked up the latest magazine at the newsstand for Pyle's newest double-page picture or spine-tingling pirate adventure.

Howard Pyle, Detail from illustration for *To Have and to Hold*, see page 46.

Pyle capitalized on the popularity of adventure fiction and delighted in producing tales of intrigue about unseemly life aboard pirate ships, in medieval castles, and along dark New York City streets in colonial times. Pirate lore particularly fascinated him. His summer home was in Rehoboth Beach, Delaware, near a coastline that at one time had served as a haven for pirates. Old-timers' stories about buried treasure and wrecked vessels whetted his imagination, as did the occasional piece of gold bullion found on the beach. On assignment in Jamaica for *Harper's,* Pyle absorbed the local color and pirate tales of the region, finding ideas for future stories. Pyle explained his attraction to the pirate: "It is not because of his life of adventure and daring that I admire this one of my favorite heroes; nor is it because of blowing winds nor blue ocean nor balmy islands which he knew so well; nor is it because of gold he spent nor treasure he hid. He was a man who knew his own mind and what he wanted."

Many aspiring illustrators grew up reading Pyle's illustrated books and revered his work. Pyle was one of America's leading illustrators and had a large following among American book and periodical readers. He recognized that there was a growing demand for illustrators in the publishing business, and he believed he could help students prepare for this work. He was eager to pass on to a new generation what he had learned by trial and error. In 1900 he opened a small school of illustration in Wilmington, Delaware. Pyle's classes differed from the standard art school curriculum by addressing the specific needs of illustrators. He selected only a few students to work in studios built adjacent to his own. Frank Schoonover, who had studied in Pyle's illustration class at Drexel Institute in Philadelphia, moved to Wilmington in 1900.

N. C. Wyeth and Philip Goodwin came from New England in 1902, and Harvey Dunn, raised on a South Dakota homestead, followed in 1904. Though the students had previous art school training, they blossomed under Pyle's tutelage in Wilmington and at his summer school in Chadds Ford, Pennsylvania. Before long they began submitting illustrations to publishers.

Pyle advised his students on how to make an illustration believable: "After you have chosen a general subject, submit it to the crucible of your own imagination and let it evolve into the picture. Project your mind into it. Identify yourself with the people and sense, that is, feel and smell the things naturally belonging there." Pyle encouraged his students to accept traveling assignments from publishers in order to get background for a story. Schoonover traveled to the Canadian wilderness of northern Quebec and Ontario in 1903. What he experienced there provided background for his "Jules Verbaux" paintings. Philip Goodwin hunted and painted in the northern Rockies, the scene of "Shooting Mountain Goats." After a trip to Colorado and New Mexico in 1904, N. C. Wyeth specialized in Western subjects for *The Saturday Evening Post:* "Hungry but Stern on the Depot Platform" illustrated a frontier story by Emerson Hough. For Harvey Dunn, the South Dakota prairie of his youth remained a favorite subject.

After first gaining attention for his Western illustrations, Wyeth launched a successful career as an illustrator. His pictures for literary classics by James Fenimore Cooper, Jules Verne, and Robert Louis Stevenson published by Scribner's achieved widespread fame. In recent years the books have been reprinted, and they continue to attract an attentive audience.

Wyeth accepted mural commissions and painted landscape and genre scenes of the Chadds Ford countryside and the Maine coast, where he summered. N. C. Wyeth recognized and nourished the creative talents of his children. The art of his son Andrew Wyeth, one of America's best-known painters, is deeply rooted in the Brandywine tradition. N. C. Wyeth was grateful for Howard Pyle's instruction and encouragement. He recalled Pyle's daily visits to the students' studios to comment on their work and offer advice: "After a hard day's work before our easels . . . who of us has not thrilled in these moments, when we suddenly heard the dull jar of the master's door, the slight after-rattle of the brass knocker as it closed, and the faint sound of his footsteps on the brick walk; then our studio door opened and he entered in the dim late afternoon light and sat among us."

By 1906 Pyle had begun directing his energies toward mural painting, and in place of daily classes he gave a weekly

N. C. Wyeth, Detail from cover illustration for *The American Boy* magazine, see page 70.

lecture and criticism session. An art colony grew in Wilmington as students settled in the area to be near the master. Young professional illustrators, who had not studied with Pyle, set up studios in Wilmington to have access to him. Schoonover stayed permanently in Wilmington, while Wyeth eventually settled nearby in Chadds Ford. In 1914 Dunn moved to Leonia, New Jersey, to be closer to New York City publishers, and he opened an illustration school, extending the Pyle tradition to a new generation of students, among them Dean Cornwell.

After Pyle's death in Italy in 1911, his former students, colleagues, and friends founded the Wilmington Society of the Fine Arts, now renamed the Delaware Art Museum, to preserve and exhibit the work of Pyle and his students. Annual exhibits were held at the Hotel du Pont and, later, at the Wilmington Library until a museum was built in 1938. The Pyle legacy continues today in the region at the Delaware Art Museum in Wilmington and the Brandywine River Museum in Chadds Ford. Both museums house renowned collections of American illustration and regularly exhibit work by the masters of this art form.

America's appetite for adventure stories continues unabated. However, in the 1950s, with the advent of television, the market for illustrated books and magazines changed; most adventure stories shifted from the print media to television and Hollywood movies. Today, family adventure films by Steven Spielberg and George Lucas are practically guaranteed box office successes. Does it come as a surprise that a young hero in Spielberg's movie *The Goonies* is spellbound by a picture of pirates dividing treasure from Howard Pyle's *Book of Pirates*?

In book and magazine illustration, as in movies and television, visuals excite the imagination. Pictures, whether painted or on film, make visible the characters, costumes, locale, and dramatic action of a story. Once you've seen N. C. Wyeth's illustration of Blind Pew, it is impossible to read Stevenson's *Treasure Island* without conjuring him up. Think of an illustrated book as a thread of words punctuated by pictures. Film and video are a logical extension of this concept: story and pictures become one.

In some instances, an illustration may even look like a movie still. Action is arrested for a moment, as if waiting for

the next sequence of shots. For example, in Pyle's scene from James Branch Cabell's "The Story of the Sestina," a disguised queen and her escort shrink in fear from their enemy. In the picture, the drama stops for an instant while we fully perceive the intrigue. Or, in Pyle's "Dead Men Tell No Tales," it's easy to imagine a long camera shot of this grisly scene before the next explosive action. Similarly, N. C. Wyeth's illustration of Sir Launcelot du Lake captures the moment in battle when the knights pause to reflect on their fate.

It's not hard to understand why movie directors and costume designers of adventure movies consult paintings by Howard Pyle and other illustrators for guidance. Pyle always advised his students to research each illustration with great care and locate authentic props and costumes for models. Pyle was a stickler for detail and consulted volumes on historical decoration, architecture, and costume in his private library. He demanded authenticity in his scenes. In "In Knighthood's Day," Pyle drew the troubadour's mandolin and horse's bridle from either actual artifacts or authentic prints, not simply from his imagination.

Illustration challenges the perceived boundaries that separate popular culture and fine art. In 1900 distinctions between contemporary art and contemporary book or periodical illustration were blurred at best. English Victorian paintings were frequently narrative in content and based on poems and legends. American artists Childe Hassam, Edwin Howland Blashfield, Kenyon Cox, and John La Farge regularly exhibited at the National Academy of Design, sold paintings to patrons, and also supplied drawings to *Harper's Monthly* and *The Century Magazine* for broader public consumption. Art exhibits at the 1893 Columbian Exposition and the 1904 St. Louis World's Fair displayed paintings and drawings for published illustrations. While the wealthy bought paintings, the middle class experienced art in the magazines. In reflecting on his career as an artist and teacher, Howard Pyle declared with pride: "I know of no better legacy a man can leave to the world than that he has aided others to labor at an art so beautiful as that to which I have devoted my life."

The breadth of this collection of adventure scenes is a marvel, reflecting a time in American history when colored illustrations in books enchanted all readers—children and adults alike. Dramatic pictures of pirates, knights, cowboys, trappers, and Native Americans lifted people from their daily existence to moments of high adventure. Today, we are still thrilled by these scenes of crisis and moments of tranquillity, of leadership and negotiation, of action and grace under pressure, and of struggle and survival. The legacy of these six artists—Howard Pyle, N. C. Wyeth, Harvey Dunn, Frank E. Schoonover, Philip R. Goodwin, and Dean Cornwell—is commemorated here for new generations of admirers.

ELIZABETH H. HAWKES

PAGES 14–15: Harvey Dunn, Illustration for "The Wrong Road," see page 78.

RIGHT: N. C. Wyeth, Detail from illustration for *The Outing Magazine*, see page 66.

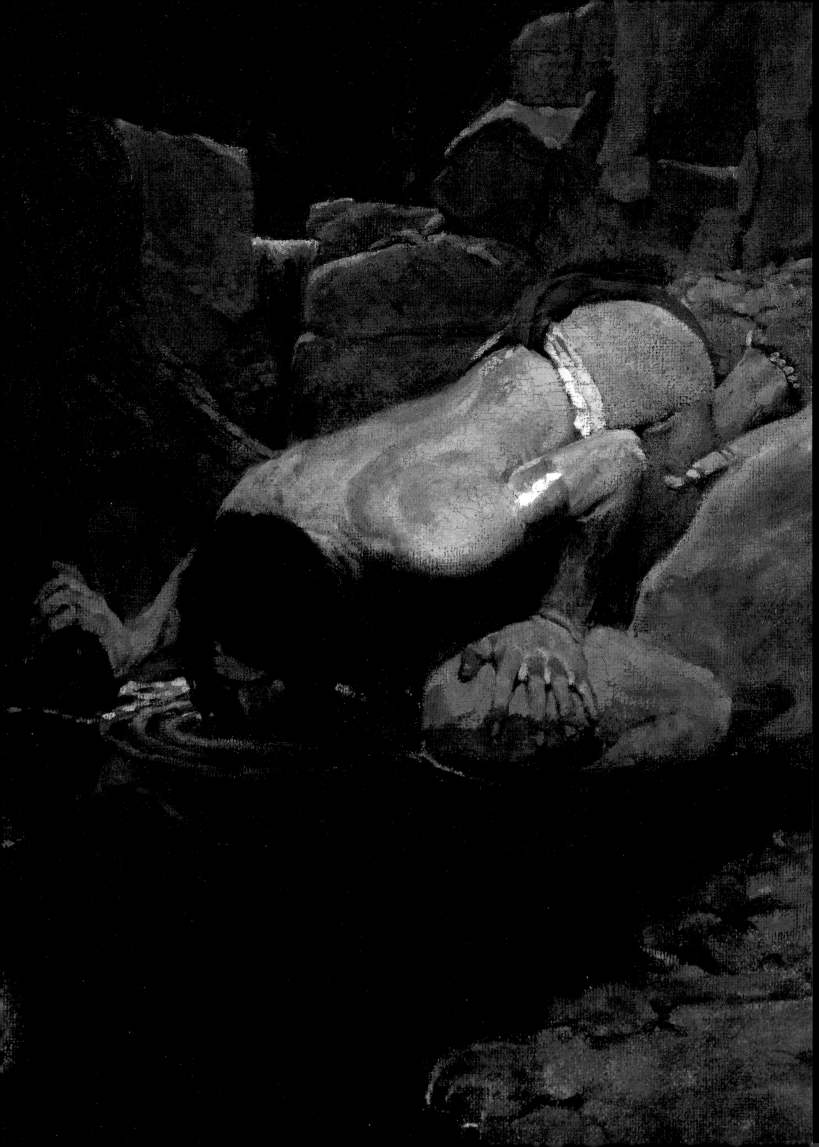

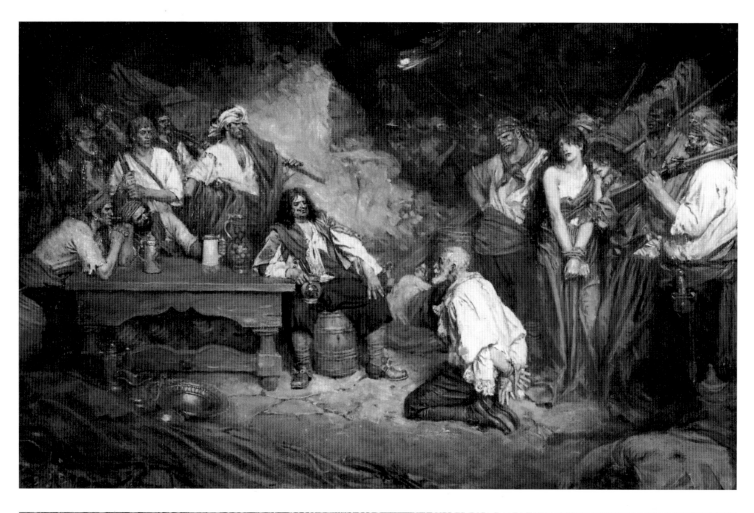

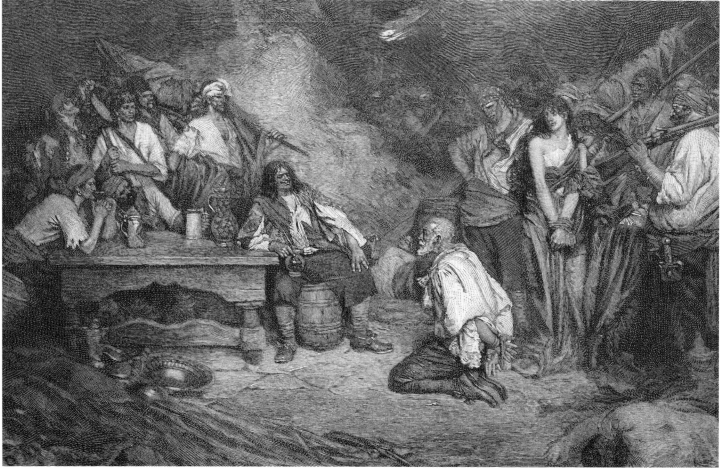

The Coming of Age of Illustration in America

THE RAPID GROWTH of publishing in America during and after the Civil War provided a new audience for illustrators. The public was particularly hungry for the pictures provided by the artists who covered the maneuvers and battles of the Northern and Southern armies. Thousands of woodcut illustrations were published in newspapers and magazines such as *Harper's Weekly* and *Monthly,* and *Frank Leslie's Illustrated Newspaper.* This method of reproducing the illustrations was slow and costly, however, and required the highly specialized services of wood engravers to translate the artwork before printing. Virtually unchanged since the invention of the printing press, this clumsy process severely limited the quality and number of illustrations that could be printed. On the facing page is an example of an original black-and-white painting in oil, by Howard Pyle, contrasted with the same subject as interpreted by the wood engraver. Lost are all of the gradations of tones, as well as the artist's hallmark painting style or technique.

Within a few years, this age-old reproduction method was supplanted—at first by line engravings produced photographically on etched metal plates, which more closely replicated the artists' original pen-and-ink drawings. These were followed later by halftone engravings, which could reproduce the tonal values of a painting or drawing by photographically breaking up the tones into a series of tiny, modulated dots. The new halftone process, in general use by the mid-1890s, cut the time required to reproduce a picture from several days to a few hours, greatly reducing the cost and improving the quality immeasurably.

Publishers could, therefore, afford to increase the number of illustrations in an issue. The public's response was enthusiastic. The artists' response was equally enthusiastic since their pictures could be published by a process that was truer to the original than ever before. The major publishers, *Scribner's, The Century,* and *Harper's,* had artists on staff, many of whom—Edwin Austin Abbey, Arthur Burdett Frost, Charles Reinhart, and Howard Pyle at *Harper's*—bridged that period of transition from wood engraving to black-and-white halftones. They had adapted their craft along with the changes in technology and were among the dominant talents in the field.

Although the halftone plates were a great improvement, most of the early ones were muddy looking because the coarseness of the screens blurred the painting's subtleties within the lightest and darkest areas. The white highlights had to be routed out by hand. Therefore, for a number of years, the production of printing plates required the craftsmanship of master engravers to achieve any subtle nuances of tones.

In 1879 magazines were given a powerful financial boost when the U.S. Congress passed subsidizing postal regulations to encourage public literacy. Subscriptions now could be mailed anywhere in the country at less than cost. Coupled with this was the development of new rotary presses that made printing faster and cheaper. The price of subscriptions could be reduced without sacrificing quality, and the number of subscribers increased as prices went down.

Soon after the turn of the century, further developments in halftone plate-making allowed the engravers to superimpose one plate over another, each inked with a primary color—red, yellow, or blue; the plates combined

TOP: Howard Pyle, "Morgan at Porto Bello." *Harper's Monthly,* December 1888, Oil on canvas, 15 x 24".
Reproduced at same size as original engraved block. Collection of Douglas Allen Jr.
BOTTOM: Wood engraving of "Morgan at Porto Bello."

to create the effect of full color. The new process, however, was very costly and restricted the number of color illustrations that could be reproduced in an issue. Pyle, who was one of the earliest illustrators to have his work reproduced by color halftone, was forced to adapt his pictures to the limitations of the new process. His first series of pictures on "The Pilgrimage of Truth" was beyond the capability of the engravers and had to be redone in a simpler form.

A vital part of this history, not often told, concerns the closeness of the collaboration between the artist, the art editor, the engraver, and the printer, who all volunteered their skills to improve an evolving and imperfect process. It is remarkable that Pyle, for instance, painted a full-color oil of great complexity depicting "The Battle of Bunker Hill," knowing that it might have to be reduced to a meager 4 1/2 x 6 1/2" in black and white [as it indeed was]. He could not have expected that the public would ever see his original, but he was motivated by the desire to advance the process. He needed to learn how color would translate into black and white and how to use color to ensure good reproduction in either black and white or color. Beyond the craft, he was driven by his artistic needs to paint a picture that would be as historically accurate as possible and true to the spirit of the action he was depicting. [Fortunately, the painting survives safely in the collection of the Delaware Art Museum and is a prime example of the art of American illustration.]

To save money, a compromise often employed by publishers was to add a single additional color plate to the black, creating a kind of duotone. Therefore, it was necessary for the illustrator to learn how to achieve the effect of a full-color painting while using only black and one second color. The majority of magazine and book artists continued to work in black and white; an appearance in full color was a privilege reserved for the special few.

The stated aims of the publishers—to present the best in literature and the latest developments in public affairs and in science—converged at the turn of the century with technological and artistic advances to produce a golden age of illustration. Advertisements were still relegated to the back section of magazines and did not assume their powerful influence in shaping much of the editorial content until after World War I.

It was against this backdrop that Howard Pyle, at the height of his powers, began to give serious thought to teaching. Aware of the shortcomings of American art schools and the fact that most aspiring artists had to complete their studies in the academies of Europe, he felt that Americans should establish their own artistic identity based on their American roots. One of his significant achievements was to show the young artists of his day how to get the most out of the technology then available.

The process of reproduction is still evolving. It has become possible to reproduce the fullest range of tone or color through the use of laser scanners. Digital technology promises to increase the versatility and manipulation of color printing even further to ensure the highest fidelity to the original paintings.

Most of the pictures included in this book were painted to be reproduced, but they have never been printed so faithfully before. Some first appeared in small black-and-white images and have never before been seen in color reproduction. One of the purposes of this book is to present these pictures for the first time as they looked on the artists' easels when freshly painted.

WALT REED

TOP: Howard Pyle, "The Battle of Bunker Hill." Oil on canvas, 24 1/4 x 36 1/8". Collection of the Delaware Art Museum.
BOTTOM: Wood engraving of the above as originally reproduced in *Scribner's Magazine*, February 1898, 4 1/2 x 6 1/2".

The Brandywine School

MOST OF THE ARTISTS who make up what is now known as the Brandywine School because of its location in the Brandywine River Valley, were students of a single powerful personality, Howard Pyle. Over an intense period in the last fifteen years of his life, Pyle shared his experience as one of America's most prominent illustrators. His students were a select group who went on to become his artistic heirs and to dominate the field for another generation.

Over the years, Pyle's advice was sought by many young art school graduates, and he was dismayed at how ill-prepared they were to enter the profession of illustration. Pyle offered to teach his innovative approach to art through classes at the staid Philadelphia Academy of Fine Art, but he was rebuffed because he was an "illustrator" and not worthy of the lofty aims of that school. Even at that early date there was beginning to be a class distinction made by art critics between "fine art" and "illustration," despite the skill demonstrated by artists such as Winslow Homer, James McNeill Whistler, and Childe Hassam. Clearly one could successfully cross over between two camps. Pyle later went on to do important mural work in addition to his illustrations for books and periodicals.

Undaunted by the rebuff, Pyle found a more receptive response at the nearby Drexel Institute. The announcement of his new course was made in the Drexel catalog for the 1894/1895 school year as follows: "A course in practical illustration in black and white under the direction of Mr. Pyle. The lectures will be followed by systematic lessons in composition and practical illustration, including technique, drawing from the costumed model, the elaboration of groups, treatment of historical and other subjects with reference to their use of illustrations. The student's work will be carefully examined and criticized by Mr. Pyle."

From the beginning, Pyle's classes were extremely successful and attracted overflow numbers. Despite an enthusiastic body of students, Pyle eventually became dissatisfied with their limited talents and with his inability to work individually with students who showed promise. Finally, after six years, Howard Pyle decided to establish his own coterie of students whom he would teach without charge in an informal "Small School of Art." Four studio buildings were constructed through the generosity of a local Wilmington, Delaware, businessman, and students were charged a minimal tuition to amortize the cost of construction. From the large number of applicants, Pyle selected those few [initially to be limited to six or eight, later expanded to twelve students per year] who demonstrated a creative individuality in their submitted samples.

Even in the best traditional art schools, the curriculum confined students within the studio walls. Among Howard Pyle's innovations at his summer course for selected students in nearby Chadds Ford, Pennsylvania, was the introduction of plein-air instruction. It enabled students to observe color and all its variations in direct sunlight and in shadow. New color theories were coming out of the French Impressionist movement, and students were encouraged to experiment with color and value in carrying out their compositional ideas. They were also being well prepared to take advantage of the new technologies for reproducing full-color illustrations in the magazines.

As N. C. Wyeth described his first meeting with Pyle in an article in *The Mentor:* "I had come to him, as many had before me, for his help and guidance, and his first words to me will forever ring in my ears as an unceasing appeal to my conscience: 'My boy, you have come here for help. Then you must live your best and work hard!' His broad, kindly face looked solemn as he spoke these words, and from that moment I knew that he meant infinitely

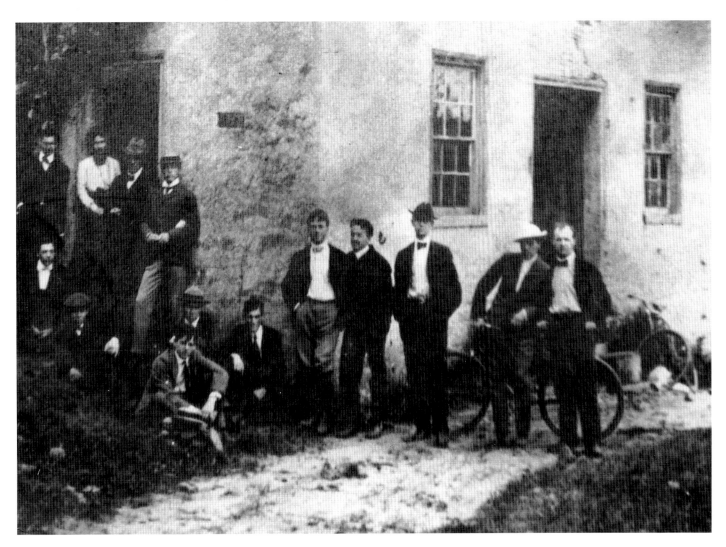

Howard Pyle's students at Brinton's Mill, site of the Chadds Ford summer classes, circa 1902. Photo courtesy of Illustration House, Inc.

more to me than a mere teacher of illustration. It was this commanding spirit of earnestness and of love that made his leadership distinctive, and that has perpetuated in the hearts of all his pupils a deep affection akin to that which one holds toward his own parents."

Pyle's greatest strength in his work and in his teaching was composition. He saw each picture as a theatrical tableau with setting and actors carefully cast and placed on the stage—or in the picture frame—in order to tell the story with clarity. No matter how well painted, a picture would be a failure if its intended message was at all ambiguous. Harvey Dunn remembered Pyle's admonition to the class: "It's utterly impossible for you to go to all the newsstands and explain your pictures."

Unlike many of his contemporaries, who were content to illustrate a transient episode in a story, Pyle was concerned with the spirit and substance of the total manuscript, which he sought to distill into pictures that could interpret the text. But he also sought to create art that could transcend the text and be independent statements that could stand on their own.

"The two arts—writing and illustrating—should," in Pyle's words, "round the circle instead of advancing in parallel lines upon which it is almost impossible to keep them abreast. Pictorial art should represent some point of view that carries over the whole significance of a situation. It should convey an image of the meaning of the text. Therefore, in illustrating a book, it is preferable to choose for an illustration some point descriptive of the text, but not necessarily mentioned in the text." Pyle's insights were particularly apt, since he was as much a writer as an illustrator and he recognized from an experienced viewpoint the appropriate balance of the two roles.

W. R.

CHIVALRY

For much of the general public, the idea of chivalry is exemplified by Camelot and that mythical kingdom of make-believe. Yet it was a powerful force in Western Europe from the eleventh through the fifteenth centuries, binding society together and culminating with the expeditions of the Crusades.

The feudal system of landed gentry supported by a force of mounted warriors and working serfs tied to the land provided a mutual-protection association that created a stable, peaceful influence in a society otherwise in flux.

The chivalric ethos also provided a code of conduct that required bravery and martial skills, loyalty to one's lord, courtesy to women, and acceptance of Christian vows for admission to knighthood. It was these ideals that appealed so strongly to Howard Pyle and to the American imagination.

Chivalry was rediscovered in the latter part of the nineteenth century and became a popular theme in art and literature. The European academies were producing artists whose subject matter was historic romanticism. Writers of historical novels were extremely popular. Even the Pre-Raphaelites of England, despite their avowed emphasis on realism, chose to paint romantic and often medieval themes. This influence was not confined to Europe; American writers and artists were caught up in the same revival, but without the nationalistic fervor of the old country.

Among the popular American writers to pursue the subject of chivalry was James Branch Cabell. His novels were published in serialized form in magazines or in books and were often illustrated by Howard Pyle. Several of Pyle's students, including N. C. Wyeth and Frank Schoonover, also illustrated medieval heroic themes.

Pyle himself wrote and illustrated four volumes of stories based on the legends of King Arthur: *The Story of King Arthur and His Knights, The Story of the Champions of the Round Table, The Story of Sir Launcelot and His Companions,* and *The Story of the Grail and the Passing of Arthur.* The first was published in 1903, and the final volume in 1910, just a year before his death. In the foreword to *The Story of King Arthur and His Knights,* he wrote a personal commentary on the project: "For when, in pursuing this history, I have come to consider the high nobility of spirit that moved these excellent men to act as they did, I have felt that they have afforded such a perfect example of courage and humility that anyone might do exceedingly well to follow after their manner of behavior in such measure as he is able to do." In the foreword to *The Story of the Grail and the Passing of Arthur,* he wrote: "I have made a study of this history and have read much concerning it; wherefore, it was my earnest wish to finish that which I had begun if God would spare me my life to do so . . ."

Pyle's book *The Merry Adventures of Robin Hood* achieved great critical acclaim for its artistic marriage of pictures and text. His *Men of Iron* became a classic description of the training of a knight and was required reading

N. C. Wyeth, Detail from "The Death of Orlando," see page 31.

in public schools for two generations. Pyle's *Otto of the Silver Hand* was a contrarily non-romantic and powerfully illustrated novel of medieval Germany.

If now, in a more pragmatic time, we see the darker side of life under medieval serfdom—the endless parochial warfare for territory and power, the terrible cost and futility of the Crusades—we can also admire the spirit that built the great cathedrals and evolved into an idealized chivalric code of conduct.

Certainly such colorful subject matter—castles and turrets, banners, coats of arms, ladies in royal dress, men in armor, the pageantry of jousting tournaments, and the clash of arms—was attractive for illustrators to exploit, and they did so with great enthusiasm.

W. R.

Howard Pyle
IN KNIGHTHOOD'S DAY

OVER SEVERAL YEARS, Howard Pyle illustrated a number of novels by James Branch Cabell. Although Pyle was not a great admirer of Cabell's writing, which he felt was inaccurate and somewhat superficial, the subject matter gave him the opportunity to deal with a colorful historical period.

In "The Story of the Sestina," a fugitive queen and her faithful escort are disguised as traveling troubadours, attempting to evade recognition and capture by a search party on their trail. Over a harrowing journey, the arrogant woman learns some lessons from encounters with common folk, gaining humility and an understanding of her subjects. Although the term "body language" was not then part of the lexicon, Pyle made full use of its principles in posing the three central figures, playing the cringing foreground couple against the erect arrogance of the knight and his huge horse. The harsh, greenish cast of light in the sky adds to a somber sense of impending tragedy. Although twilight, it was not yet dark enough to conceal the fugitives from recognition.

Pyle, as a good dramatist, did not give away the plot. In fact, a principal function of the illustration was to induce the casual browser to read the story. Here the question is still open—will the couple avoid capture?

After the novel's publication, Pyle gave this picture a new title, "In Knighthood's Day," indicating his regard for it as a painting independent of the story.

W. R.

"They were overtaken by Falmouth himself." Illustration for "The Story of the Sestina," in *Chivalry*
by James Branch Cabell, New York: Harper & Brothers, 1909, facing page 14. First published in January 1906
in *Harper's Monthly*. Oil on canvas, 24 x 16", signed lower left.

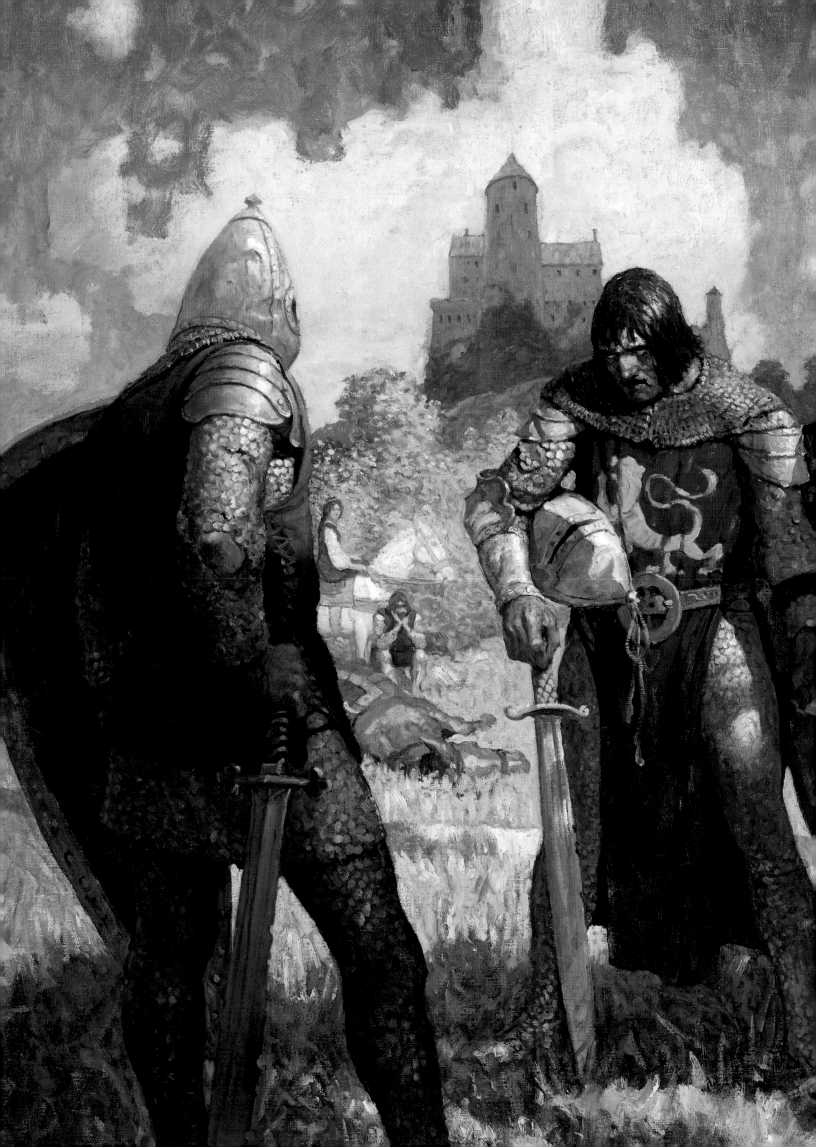

N. C. Wyeth
Sir Launcelot

After two hours of fierce struggle, Sir Turquine [in blue] has offered a truce and oath of friendship provided his anonymous opponent is any knight in the land except Launcelot du Lake, the slayer of Turquine's brother. Launcelot's dramatic self-identification is visually expressed here by his literal "unmasking."

Wyeth may have recognized parallels between the brutality of the medieval era, which he described in a letter as "rich in picturesqueness but black with infamy," and the Great War unfolding at the time of this work. Though he executed propaganda pieces for the war department while illustrating this book, he made little secret of his extreme ill-ease with American war fever. Whatever the reason, this group of illustrations is replete with harsh touches—like the fallen horse at the center of this composition—that belie the romance of the scenes.

Wyeth applied the idealism of the fine artist to his commercial work with unprecedented intensity. During his prime impressionist period—roughly from 1913 to 1920—he was at his most prolific. He applied techniques to illustration that, though well established in "serious painting," were revolutionary within illustration.

"Sir Launcelot" is a good example of this unaffected integration. Around 1915 Wyeth added a dose of Neo-Impressionist color theory to his already well-developed love of broken brushwork and impasto. Despite his seriousness of purpose, he seldom allowed modern technique to overwhelm the necessities of narrative. One could argue that the resulting mélange of technique marks Wyeth as a dabbler. From our perspective, it is apparent that he was operating, successfully, in the best traditions of American painting. From Homer to Hopper, American artists have been refreshingly unencumbered by manifestos, preferring to employ whatever worked.

The basic idea of Neo-Impressionism—that juxtaposed strokes of brightly colored paint will blend in perception much more vibrantly than those resulting from physically mixing different pigments—is theoretically impeccable, yet the idea in application sacrifices detail and hinders immediacy of execution, both key concerns of Wyeth's. In "Sir Launcelot" Wyeth has applied such color theory only narrowly to the illusionistic depiction of direct sunlight and attendant shadow, which requires extreme contrast. The figures are the focus of attention and are rendered straightforwardly and in considerable detail. The landscape elements, however, are built up from vivid strokes of non-local color. Infusing the shadows cast on the grass with bright strokes of red and blue retains their darkness while permitting us to peer into the shade.

The successful integration of his innate fascination with the rendering of plastic form, the idealism of Howard Pyle, and a host of Post-Impressionist ideas and methods set a new standard that few subsequent illustrators were able to maintain.

C. F.

"I am Sir Launcelot du Lake." Illustration for *The Boy's King Arthur* by Sidney Lanier,
New York: Charles Scribner's Sons [A Scribner's Illustrated Classic], 1917, Frontispiece.
Oil on canvas, 39 ¼ x 31 ¼", signed lower right.

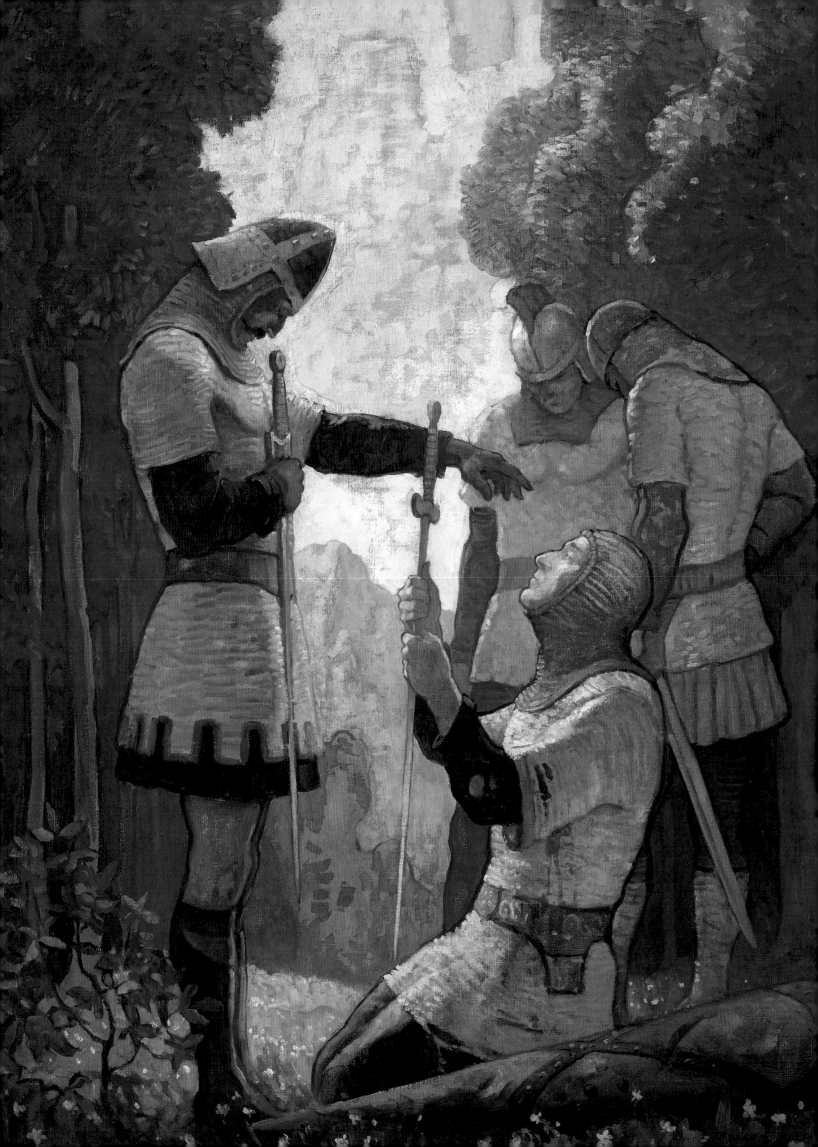

N. C. Wyeth
THE DEATH OF ORLANDO

THE LEGENDS OF CHARLEMAGNE recounts the epic adventures of the eighth and ninth centuries as Charlemagne battled against the Moors. This painting shows his trusted knight, Orlando, near death after being betrayed to the enemy. At the close of a long, bloody battle, he has summoned Charlemagne by blowing for help on the great hunting horn, pictured in the lower right. He is mortally wounded, yet rejoices upon learning of victory from his mournful friends. Now Orlando kneels, composing himself for death, and begs absolution as he gazes at the crucifix hilt of his sword.

Wyeth strove to communicate his reverence for universal spirituality in his paintings. His aesthetic sensitivity was enriched by constant soul-searching and by his intellectual drive. The scene of Orlando's noble death gave him free rein to depict man's confrontation with the eternal. The harmonies of seraphic blue shimmer in ethereal light. The leaves on the tree and the knight's mail are illuminated with transcendent hues. Wyeth infused his paintings with a mystical devotion, from a patch of bark to the infinite sky, in a lifelong quest to appreciate and capture the profundity of the universe.

N. C. Wyeth carefully chose his distinct colors to communicate his emotions. As early as 1908 he related in a letter to his mother his excitement over the sensation of feeling color harmonies unique to his temperament, and he expressed the desire to create a color palette of his own.

In "The Death of Orlando," Wyeth used the technique of laying pure color directly onto the canvas and surrounding it with white, creating a refraction of light that increases the sensation of overall luminosity. This practice let Wyeth retain the brilliance of the hues—essential for expressing the wonderment of the scene. Light seems to emanate from the entire surface of the picture, despite its little use of shadow. As in other works, Wyeth establishes an additional light source on the central figure. It spotlights and shines beatification on Orlando's upturned, pious face.

V. M.

"Orlando fixed his eyes on the hilt of his sword as on a crucifix, and appeared like a figure, seraphical and transfigured,
and bowing his head, he breathed out his pure soul." "The Death of Orlando" illustration for *The Legends of Charlemagne* by Thomas Bulfinch,
New York: Cosmopolitan Book Corporation, 1920, facing page 198. Oil on canvas, 33 ¼ x 24", signed.

N. C. Wyeth
STALKING THE ENEMY

THE BLACK ARROW: A TALE OF THE TWO ROSES is a historical romance set in fifteenth-century England. It is the second Robert Louis Stevenson book after *Treasure Island* that N. C. Wyeth contracted to illustrate for the Scribner's Classic series. He admired Stevenson's writing and relished the opportunity to again illustrate one of his novels.

Disguises, outlaws, bloody battles, priests, and a country overrun with stragglers from warring armies create an adventure with action and vivid characterization. N. C. Wyeth captured the essence of the warring medieval times in his endpapers. He depicted the men of the Black Arrow stalking the enemy—poised with hands clasped around their bows and arrows. Their faces are tough, their jaws set, and countenances determined. Their bodies crouch, always ready to attack or to be attacked as their strong legs carry them into the deep, untamed forest.

By placing one huge tree in the center of the picture, Wyeth adeptly symbolized an entire forest. Although not highly detailed, the tree is beautifully and simply rendered in modulating tones of black and white. Using a subtle light filtering through the dense background and across the massive trunk, the artist suggested the denseness of a thick forest. The open whiteness of the lower half of the picture forcefully contrasts with the darkness of the woods, the war, and the medieval period.

Illustration requires more than just the expertise and craft of painting. N. C. Wyeth read extensively and understood the authors whose stories he visualized and communicated. Attention to exact details such as longbows, spears, doublets, mail, and quarterstaves was essential. In thoroughly researching the details of medieval dress, language, and mannerisms, Wyeth followed Pyle's lead. He accumulated pieces of authentic costuming and dramatized a scene or action whenever possible. His involvement with detail was so consuming that the book became part of his everyday life. Having internalized the black and warring mood of the medieval period, Wyeth reveled in the panoramic visual pageantry of these chivalrous times but despaired at the depressing legacy of brutality, treachery, and war.

According to his letters, painting freed Wyeth from the emotional turmoil he experienced in his in-depth study of those perverted times. He released his passions on the canvas.

V. M.

Illustration for *The Black Arrow: A Tale of the Two Roses* by Robert Louis Stevenson, New York:
Charles Scribner's Sons [A Scribner's Illustrated Classic], 1917, Endpapers.
Oil on canvas, 25 ½ x 35 ¼".

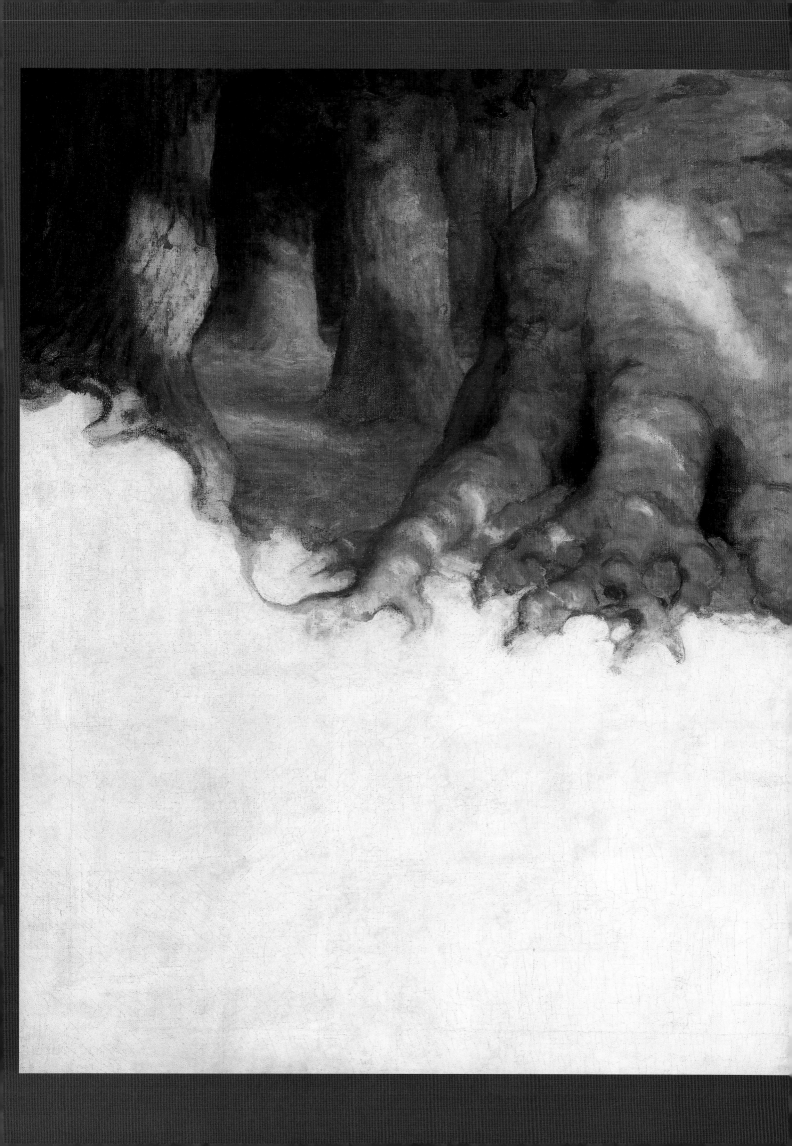

N. C. Wyeth
THE WHITE COMPANY

ALTHOUGH ARTHUR CONAN DOYLE is now best known for his Sherlock Holmes stories, he was also the author of many other novels—among them his two stirring tales about Sir Nigel, a companion to the White Company. For Wyeth this story of Nigel, a seasoned elder warrior with his band of Saxon yeomen, was a welcome illustration assignment and familiar territory to him. He had previously illustrated several books dealing with life in the Middle Ages including *The Black Arrow, The Boy's King Arthur, The Mysterious Stranger, Robin Hood,* and *The Legends of Charlemagne,* and was very knowledgeable about arms, heraldry, and the manners and mores of that rigorous and dangerous period.

In spite of his familiarity with the era, Wyeth conscientiously prepared himself further for this project by reading Sir Walter Scott's *Ivanhoe* and the *Chronicles of Froissart.* And, as was his practice, he followed Pyle's advice to immerse himself in the emotional roles of the characters, becoming of the "Company" himself. The physicality of the story, reflecting Doyle's own youthful athletic exploits, called for the kind of heroic figures that were Wyeth's hallmark.

This story records the contention of the English, French, and Spanish forces for the dominance of Europe in the fourteenth century. It also marks the decline of the old feudal barons in England and the gradual rise of a more democratic society. Doyle, unlike many writers about the feudal era, centered much of the interest in the story on the common folk and their role in that structured hierarchy, rather than placing the usual emphasis on the nobility.

The long bow had become a new force in warfare, a change from the former reliance on the sword, spear, and pike. The subject of the cover illustration was chosen by Wyeth to symbolize that revolution in battle strategy. As a picture, the subject is treated almost as a poster with the strongly silhouetted archers in the foreground set against billowing white clouds and a battery of archers in direct sunlight. They are attacking invisible foes below, who are only revealed by the upward rush of countering arrows. No indication of a victor is given and the reader is strongly led to read the book to learn the outcome.

W. R.

Cover illustration for *The White Company* by Sir Arthur Conan Doyle,
New York: Cosmopolitan Book Corporation, 1922. Oil on canvas, 42 x 30", signed and inscribed
lower right. Photo courtesy of Illustration House, Inc.

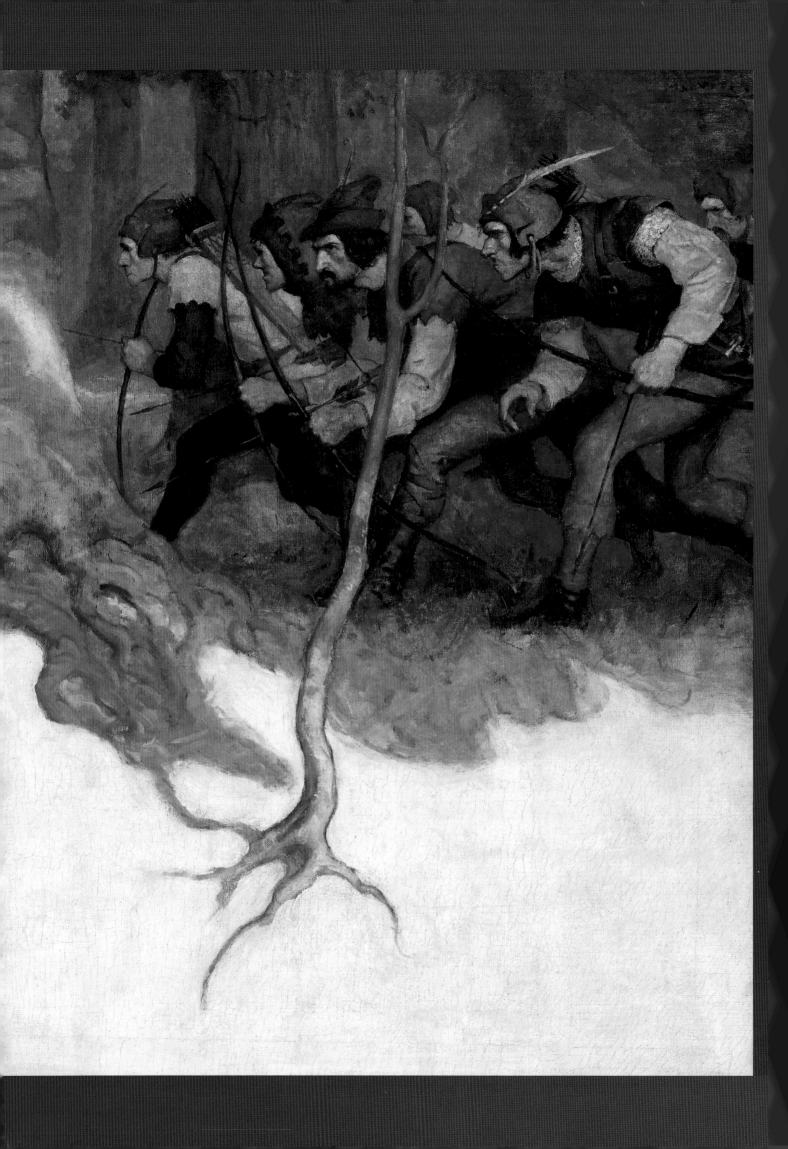

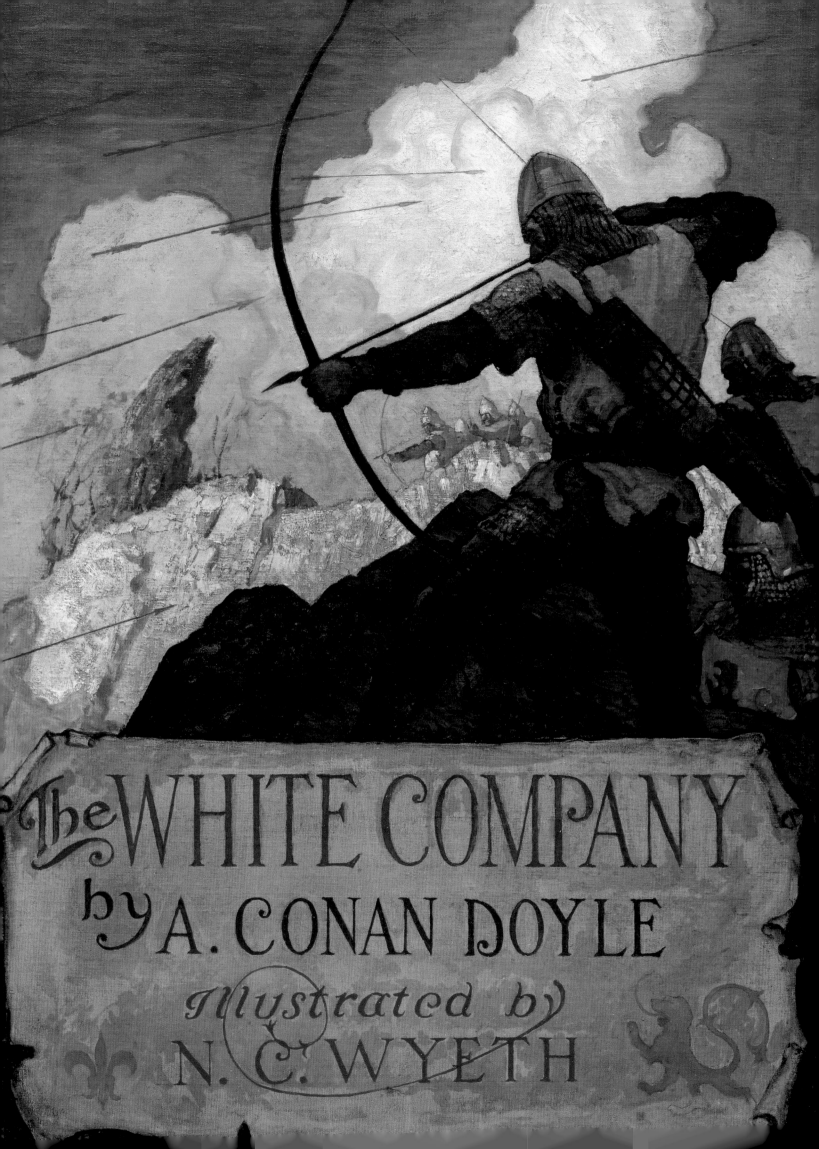

The WHITE COMPANY
by A. CONAN DOYLE
Illustrated by
N. C. WYETH

PIRATES

BEYOND NATIONAL SOVEREIGNTY and the surveillance of law and order, the high seas have always provided an opportunity for the strong to prey on the weak. Even nations nominally at peace have used privateers to harass and rob one another's ships. The sluggish Spanish galleons, transporting treasure from the New World, were a favorite target of Sir Francis Drake and others under Queen Elizabeth I.

It was the thousands of freebooters, however, who were the real scourge of international shipping—particularly in the Caribbean, where there were innumerable places for ambush, hundreds of unarmed passing ships, and defenseless coastal settlements to pillage and rape. Certain pirate captains became known for their brutality and were vigorously hunted by naval men-of-war. When pirate ships were captured, the British summarily hanged the captain and the entire crew. Some pirates, such as Captain Kidd, Edward Teach [Blackbeard], and Captain Morgan, became part of legend as their exploits were recounted in the chapbooks of their day.

Still, at the turn of the century there was little public awareness of pirates until Howard Pyle undertook a systematic study of their history and began to write about them in articles, illustrated novels, and short stories. In August and September of 1887, Pyle published a two-part paper in *Harper's Monthly* entitled "Buccaneers and Marooners of the Spanish Main." The paper was illustrated with graphic paintings that portrayed the "Sacking of Panama," "A Marooned Seaman," and "Walking the Plank," among other powerful subjects. Much of our contemporary conception of pirate images and practices can be traced directly back to Pyle. Certainly N. C. Wyeth's famous illustrations for *Treasure Island* and Frank Schoonover's *Yankee Ships on Pirate Waters,* among others, owe a great deal to Howard Pyle. In the paintings that follow we can see some of Pyle's finest work—alongside that of his students, who created masterpieces of their own.

After Pyle's death, most of this material was gathered together by Merle Johnson into a single volume, *Howard Pyle's Book of Pirates*, published by Harper & Brothers in 1921. Since that time the book has served as a fascinating documentation of the era and a guide to other artists, as well as to writers like Robert W. Chambers and Rafael Sabatini. Some of the scenes in the film *The Black Pirate,* starring Douglas Fairbanks Sr., were directly based on Pyle's tableaux. Similarly, Errol Flynn's *Captain Blood* was based on Pyle's concepts [as well as Sabatini's].

It is interesting to conjecture how the peace-loving, Quaker-born Howard Pyle could so convincingly empathize with such a subject. Pyle answered that question with his own questions in his *Book of Pirates:*

> Why is it that a little spice of deviltry lends not an unpleasantly titillating twang to the great mass of
> respectable flour that goes to make up the pudding of our modern civilization? And pertinent to

N. C. Wyeth, Detail from illustration from *Treasure Island*, see page 42.

this question another—Why is it that the pirate has, and always has had, a certain lurid glamour of the heroical enveloping him round about? Is there, deep under the accumulated debris of culture, a hidden groundwork of the old-time savage? Is there even in these well-regulated times an unsubdued nature in the respectable mental household of every one of us that still kicks against the pricks of law and order? To make my meaning more clear, would not every boy, for instance—that is, every boy of any account—rather be a pirate captain than a Member of Parliament?

Certainly it was Pyle's vivid imagination that allowed him to so intimately visualize pirate actions. It was partly the colorful subject matter of motley characters, assorted weaponry, and antiquated ships that appealed to him as an artist. As a writer, he was attracted by the high adventure and the chance to tell an exciting story of unabashed villainy—and, in the end, he could bring the perpetrators to their well-deserved fates, which reconciled the telling of the story with his Quaker sense of morality. In the process, we can, with Pyle, secretly enjoy the vicarious pleasure of rapscallion derring-do.

W. R.

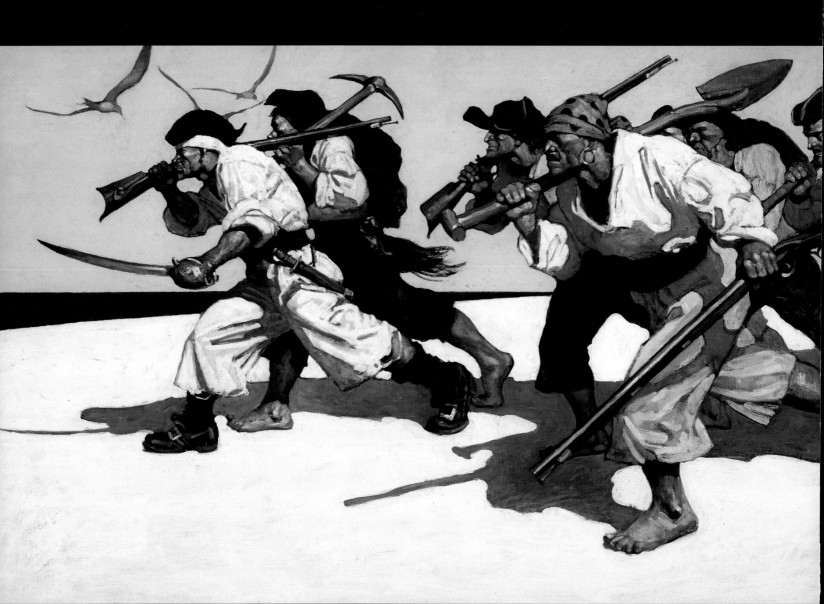

N. C. Wyeth
TREASURE ISLAND

THIS DRAMATIC PAINTING became the endpapers to *Treasure Island,* the first book in the famous Scribner's Classic series to be illustrated by N. C. Wyeth. The graphic style of endpapers on the inside cover is intended to capture the reader's interest on opening the book. This edition of *Treasure Island* unleashed a powerful synergy between the literary genius of Robert Louis Stevenson and the brilliant imagination and visual interpretations of N. C. Wyeth. Stimulated by the thrilling adventure of a boy marooned on Treasure Island with villainous pirates and by the story's vivid personalities, Wyeth made his exuberant images explode on the canvas.

Across the wide expanse of the inside cover stalks an evil-looking gang of pirates. Wyeth paints the figures large in scale to dramatically fill the space and to create a sense of presence, strength, and power. They are in motion, running across the page with long sure strides, feet defiantly stamping the sand. Their physical attitude demonstrates definite purpose and determination. Faces are clearly painted with intensity. Powerful jaws thrust forward over muscular arms and legs. The composition creates a sense of speed and movement. The figures are bisected by the edge of the page as they emerge from the right side. A partial face and arm on the right and the open space on the left advance these buccaneers across the page.

The background is undefined to avoid cluttering the image of the advancing pirates. Yet the broad white space on the bottom half of the painting communicates a beach, and the brilliant golden sky clearly suggests the hot beating sun of an island.

The mutineers are carrying shovels, guns, pickaxes, cutlasses, and daggers—lethal instruments for digging treasure and fighting enemies or one another. These tools and weapons are prominently painted, sending a clear message of the pirates' mission. No one stands between these men and their treasure.

V. M.

Illustration for *Treasure Island* by Robert Louis Stevenson, New York: Charles Scribner's Sons
[A Scribner's Illustrated Classic], 1911, Endpapers. Oil on canvas, 30 ¼ x 46 ¼". Collection of Brandywine River Museum.
Purchased in memory of Hope Montgomery Scott.

N. C. Wyeth
Captain Smollet Defies the Mutineers

TREASURE ISLAND is the story of a young lad, Jim Hawkins, leaving home for the first time to seek his fortune with a motley crew of sailors, whom he discovers are diabolical "gentlemen of fortune." Armed with a dead pirate's map, he boards a ship bound for a Caribbean island, searching for buried treasure. The surly crew mutinies when they reach Treasure Island, and a race begins between the rowdy pirates and the ship's distinguished company—squire, doctor, and captain. With Jim in the middle, they battle for their lives and for the treasure.

This is the quintessential adventure story of a boy coming of age by receiving the ultimate opportunity—to sail at sea on a ship searching for treasure. The pirates represent an unruly and glorified freedom of wild abandon and lawlessness that refuses to conform to any rules except its own twisted code of ethics.

In contrast to the bloodthirsty pirates swarming throughout the book, Wyeth chose to portray the stolid Captain Smollet and his gentlemen in this painting. Disregarding the seething chaos and danger around him, Smollet calmly and decisively reacts to the crisis with a clear sense of the available options. A true leader, he directs the remaining honest men to an eventual victory against the odds. Despite the mutiny, they appear collected and remain properly dressed. Attentive to Pyle's teaching, Wyeth is accurate in his historical detail. Their clothing is correctly indicative of men's fashion of the late eighteenth century, complete with powdered wigs, which are still intact after the mutiny. Even though the barricade is surrounded by rum-soaked mutineers, Smollet, with strength and dignity suitable to a captain in His Majesty's Navy, climbs on top of a blockhouse and raises the British flag on a trimmed fir tree.

In choosing the defiant image of Captain Smollet as he raises the British colors, N. C. Wyeth demonstrates the nobility and decorum of the ousted leadership in the face of the lawless mutineers. He painted Captain Smollet standing erect, oblivious to danger, feet firmly planted on the dilapidated blockhouse. In contrast to the Jolly Roger illustrated on the book's front cover, the flag here is the red, white, and blue of England's Union Jack. The mood is somber, but the painting is gloriously lit by the setting sun.

V. M.

"Then climbing on the roof he had with his own hand, bent and run up the colors." Illustration for *Treasure Island* by Robert Louis Stevenson, New York: Charles Scribner's Sons [A Scribner's Illustrated Classic], 1911, facing page 138. Oil on canvas, 46 ¹/₁ x 37 ¹/₁", signed lower right. "Captain Smollet Defies the Mutineers." Collection of the Brandywine River Museum. Purchased through the generosity of Mr. and Mrs. Bayard Sharp.

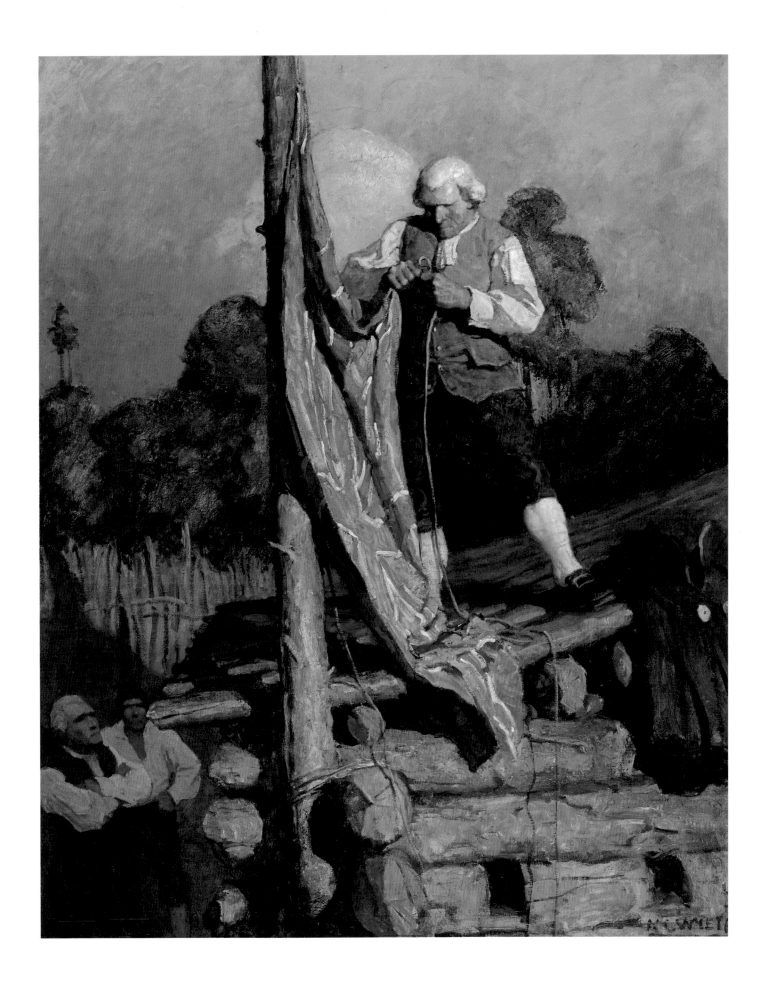

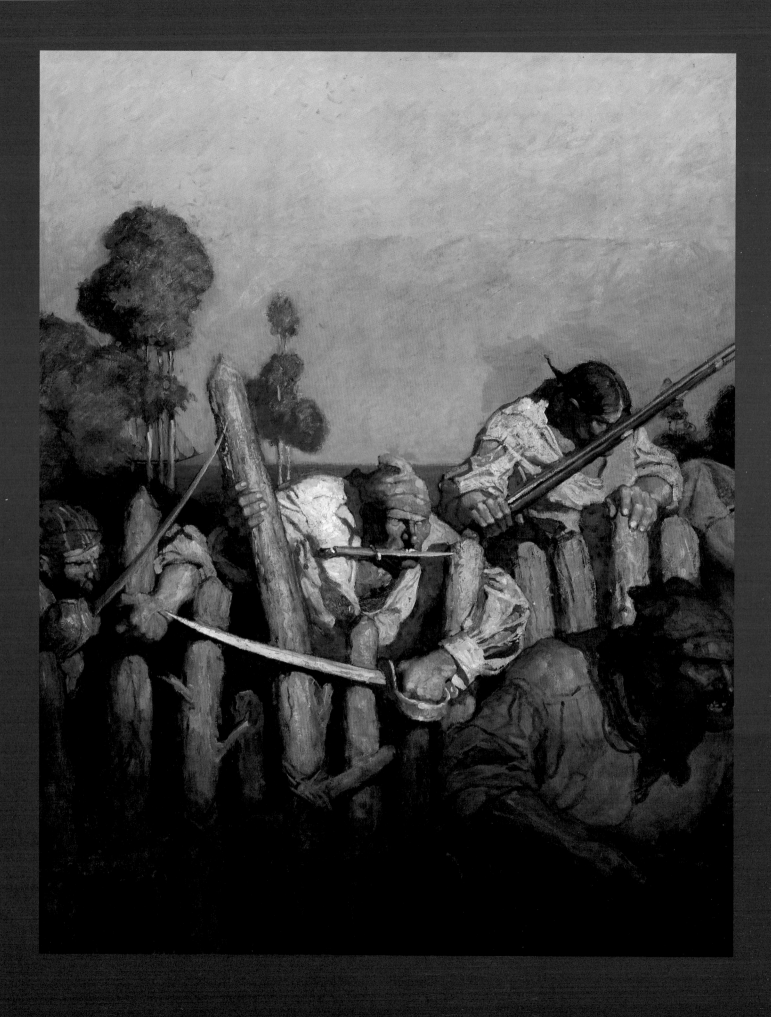

N. C. Wyeth
OVER THE BARRICADES

LONG JOHN SILVER, Billy Bones, Ben Gunn, Black Dog—these are marvelous names for pirates that, along with N. C. Wyeth's images, still conjure up our concept of pirates today.

Wyeth's careful attention to authentic coloring and nautical material from the eighteenth century combined with his personal vision are the essence of *Treasure Island*. As early as 1916, Wyeth's images were used on the stage at New York's Punch and Judy Theater for a production of *Treasure Island*, which followed his types and costumes almost exactly. Most recently, in 1990, Charlton Heston played Long John Silver in a feature-length film for television, with sets and costumes derived from N. C. Wyeth's original paintings.

There were no buccaneers to pose as models, so Wyeth had to picture these characters in his mind before he could paint them. No one could have held the position of scrambling over a barricade in order for Wyeth to paint the action from reality, but these figures have the right mass, form, muscle, and presence. The faces are angular, broad, and vicious, with hard, contoured cheekbones. Unlike the maniacal faces Pyle often portrayed, the faces of Wyeth's pirates have romanticized cruelty that is fierce and robust.

Wyeth's light source focuses on the center pirate, who is brandishing a dagger between his teeth and holding a cutlass. By leaving the remainder of the painting in shadow, Wyeth draws attention to this grisly face and the sinister metal of weapons reflecting the sun.

The composition of the various guns, swords, and pistols pointing in different diagonals creates a sense of disarray and disorder as the pirates swarm over the stockade. The vertical lines of the fence span almost half the picture plane, creating the sense of a barrier, but by placing the pirates both in the foreground and behind the fence, Wyeth fills the picture plane with action as they silently clamber over it. The romantic colors of the blue sea and the pink sky behind these fiends accentuate the feeling of danger intruding on the island paradise.

V. M.

"The boarders swarmed over the fence like monkeys." Illustration for *Treasure Island* by Robert Louis Stevenson, New York: Charles Scribner's Sons [A Scribner's Illustrated Classic], 1911, facing page 162. Oil on canvas, 46 ¼ x 37 ¼", signed. "Attack on the Block House." Collection of the Brandywine River Museum. Purchased through the generosity of Mr. and Mrs. Bayard Sharp.

Howard Pyle
I Had Met My Equal

Pyle painted several pirate dueling pictures; this is one of his best. Surrounded by the sinister crew, the contest is a pitiless spectacle that the viewer vicariously joins.

In the action depicted, the hero has made a desperate move to save his life by challenging all comers to replace the fallen pirate captain. The challenge is taken up in quick succession by three of the best swordsmen. Here, exhausted, he is fighting for his survival against the last—and best—of his opponents.

Pyle has given us a strong diagonal composition to emphasize the thrust and parry of the swordplay. He has set the stage with the onlookers, the strip of ocean, and the trampled sand, which indicates the long duration of the fight.

Pyle's unique contribution to illustration can be considered a parallel to Konstantin Stanislavsky's concurrent development of "method" acting. Both systems employed the burgeoning awareness of psychology as it related to a person's behavior. When Pyle exhorted his students to "project your mind into your subject until you actually live in it," he meant that they should go beyond the information provided by the text, to "inhabit" their characters so that they could intuitively know how the subjects would react to a situation, what gestures they would make, what clothes they would wear.

When used in composing a strong picture, this method is as powerful as it is on stage. It imbues the characters and their actions with authenticity. This invention of "method painting" revolutionized the illustration field and elevated it to an art form that has seldom been properly perceived by art critics and museum curators.

In keeping with this approach, Pyle would have become as absorbed with the contest as any of the pirates. He would have been keenly aware of the shifting sand underfoot, the clashing of steel blades, the oaths, the hot sun, and the sweating bodies while he painted the action of the scene as he personally felt it.

W. R. & R. T. R.

"Why don't you end it?" Illustration for *To Have and to Hold* by Mary Johnson,
Boston and New York: Houghton Mifflin and Company, 1900, Frontispiece. Oil on canvas, 17 ¹/₂ x 11 ¹/₂", signed.
Courtesy of the Kelly Collection of American Illustration.

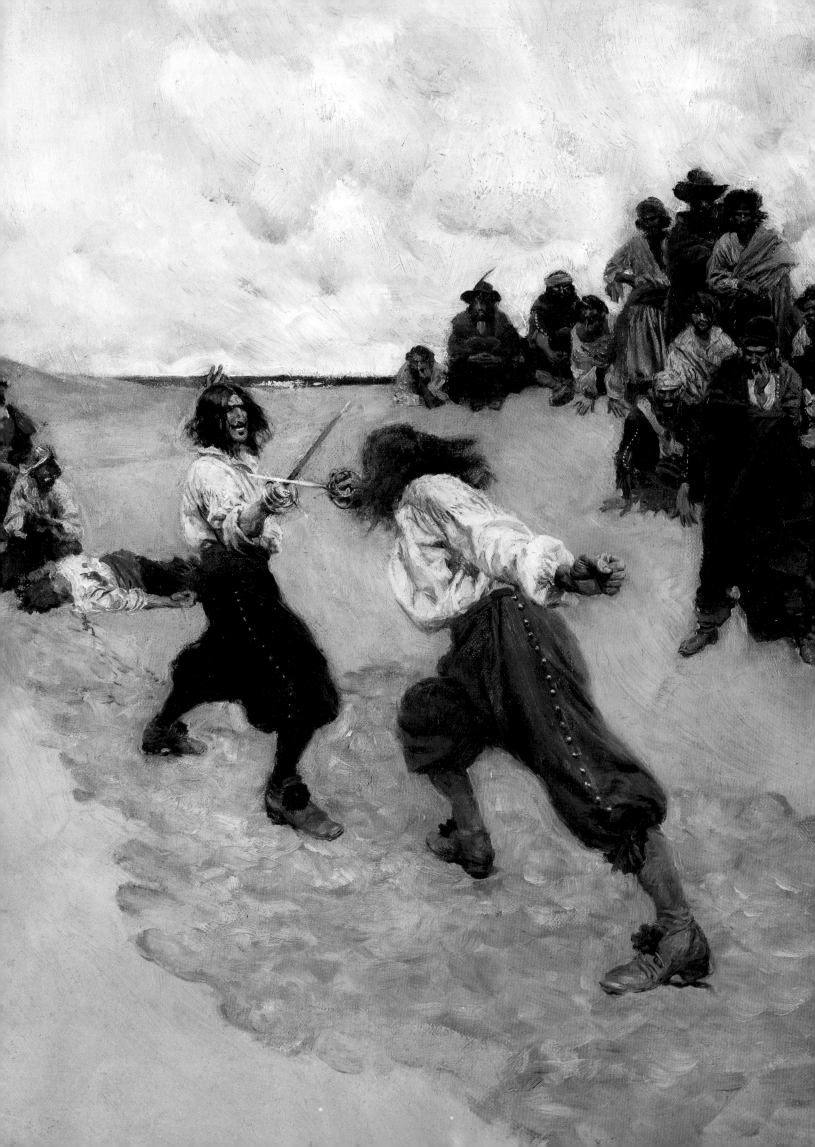

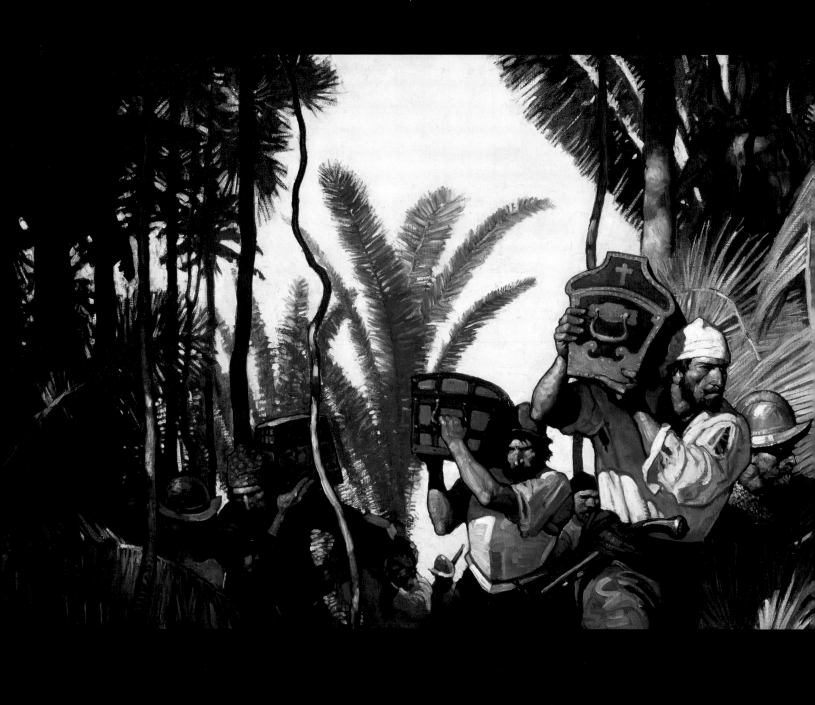

N. C. Wyeth
NEW WORLD TREASURE

IN WESTWARD HO! young Amyas Leigh of Elizabethan England seeks adventure on the high seas of the New World and finds it in duels, sea battles, and raids on Spanish towns filled with treasure. After the heroic defeat of the Armada, he retires from the sea to live as an English lord. With his mother's blessings, he marries the beautiful Indian maiden who aided him in gaining vital tribal allies. The book tells of another side of buccaneering. Peers of both Spanish and English nobility were sometimes friendly fellow-adventurers and sometimes battled each other for their countries as well as for personal fortune on the wealthy Spanish Main. These are not the bloodthirsty pirates of *Treasure Island;* treasure was won honorably in a gentlemen's war.

Pictured here are the typical Wyeth adventure figures: strong faces and muscular bodies bursting with energy. Carrying their treasure hoisted upon their shoulders, they cut a path through the dense jungle of the New World. Unlike in the *Black Arrow* and *Treasure Island* endpapers, here Wyeth doesn't rely on the men's legs to show their bold advance. By painting only their tilted upper bodies, he accentuates the weight of the treasure. Wyeth achieves the sense of dramatic action by using strong patterns of light and shadow.

This composition enfolds the viewer into the painting at a point directly facing the privateers. The vine on the left divides the space in front of the advancing figures. In the background the white paint appears layered on top of the dark palm fronds, intensifying the impression of shimmering tropical light. The men advance from the dense darkness into the sunlight. The thickness of the jungle is apparent in the dappled light against the dark shadows and the mass of vines surrounding the swashbucklers.

The painting is a fine example of how Wyeth imparts action and drama with minimal color and physical motion, within the strictures of the limited color allotted for printing.

V. M.

Illustration for *Westward Ho!* [Or *Voyages and Adventures of Sir Amyas Leigh*] by Charles Kingsley,
New York: Charles Scribner's Sons [A Scribner's Illustrated Classic], 1920, Endpapers.
Oil on canvas, 27 $^1/_4$ x 4 $^1/_4$", signed, circled "W" upper right.

Dean Cornwell
CAPTAIN BLOOD

CORNWELL'S ILLUSTRATIONS FOR Rafael Sabatini's stories, such as this one, are orderly and controlled tableaux. They bear as much similarity to pirate life as Warren Beatty's film *Bugsy* did to Mr. Arthur Siegel. Cornwell's marauders do not smell bad, and they do not have scurvy. But by 1930, the general American audience was tired of gritty realism. We can imagine his teacher, Harvey Dunn, shaking his head, remembering Cornwell's earlier work, which was so much more like his own gutsy and wild compositions.

But even as he reached his height as an illustrator in 1923, Cornwell was already looking for a new vocabulary to incorporate into his work. This he found in Frank Brangwyn's mural paintings and mosaics—a more decorative, graphic style, which also looked good on the printed page. Although Cornwell thoroughly steeped himself in the Brangwyn method, again becoming a "sedulous ape," in his words, he never abandoned his Brandywine roots and reportedly would answer telephoned questions to Brangwyn's studio about that master's methods by quoting Dunn's aphorisms. Dunn taught his students by quoting Howard Pyle, mixed with his own philosophy. The "Dunn aphorisms" were absorbed by Dean Cornwell and passed on, even when the questions related to the work of Frank Brangywn.

This illustration, "Captain Blood had walked into a trap," is a powerful work from Cornwell's later period. The bold, sculpted shapes painted in thick and assured strokes are a Brangwyn trademark. This painting uses only black, white, and orange pigments; Cornwell's frequent use of a limited palette was a typical restriction of budget [the magazines were quite frugal in their use of color]. Cornwell, though, excelled at meeting this constraint. The viewer isn't given the impression that something is missing from these two-color paintings.

This work bears an affinity to the endpapers paintings by Wyeth in this volume. They employ a graphic approach, silhouetting the shapes of the figures against light-colored backgrounds by using outlines—essentially a muralist's technique. The same effects that make a mural stand away from the wall work for the magazine page in miniature: the image catches the reader's attention very effectively.

Working together with this broad pictorial design is Cornwell's later tendency to depict his characters more broadly. As his career continued into the thirties, his characters become more stock, especially in his treatment of historical subjects. His Captain Blood here is more icon than individual, a kind of glamorized *Übermensch* swashbuckler, more in tune with the Hollywood *zeitgeist*.

 R. T. R.

"*Captain Blood had walked into a trap. It was too late to retreat.*"
Illustration for "The Blank Shot" by Rafael Sabatini, *Cosmopolitan*, 1930.
Oil on canvas, 25 x 48", initialed lower left.

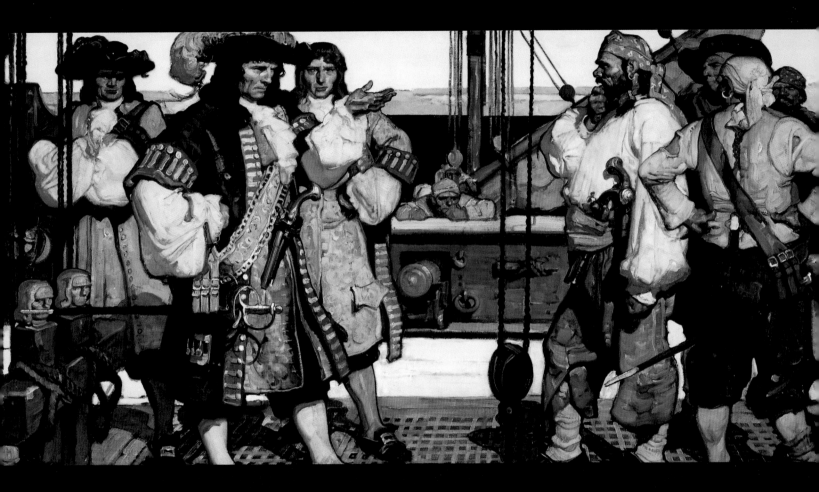

Howard Pyle
DEAD MEN TELL NO TALES

THIS PAINTING HOLDS a special place in Pyle's oeuvre. It was not designed to illustrate a story but stood alone, much the way many nineteenth-century salon paintings have a literary theme. Nevertheless, it was meant for reproduction and is assuredly narrative, as is clear from a letter Pyle wrote to Mrs. Merton McDonald, an inquiring correspondent, in 1900:

> My pirate picture may be explained as follows: The captain of the pirate vessel and the first mate called upon three of the crew and together they have carried a chest of treasure up among the sand hills on the Atlantic Coast just below the mouth of Delaware Bay. They needed to revictual and water the ship, and were afraid to carry the chest of treasure aboard lest one of the King's cruisers, upon the lookout for pirates, should search them and find their ill-gotten gain.
>
> The pirate captain and the mate had already arranged between them that the fewer who knew such a secret the better. Consequently when the treasure was safely buried and a cross thrust down into the sand to mark the hiding place [for before their return a storm might so level the sand as to make it impossible to discover the exact spot where the treasure was hidden] they immediately proceeded to put out of the way the unfortunate witnesses of the secret.
>
> The mate shot two of the men as they stood together resting from their toil—the one with one pistol and the other with the other. The third victim started to run, but the captain running almost parallel with him and cutting him off at the edge of a little bluff, knocked him over with a single clean and well-directed shot.
>
> As the situation now stands the mate has no load in either of his pistols and the captain has one pistol, which is yet loaded.
>
> I do not know what happened after I drew my picture.

This remarkable narrative exhibits Pyle's aim to unite text and image, especially as the text doesn't derive from any novel he was given to illustrate. Just the opposite; the painting dictates the text, and thus achieves an ideal for Pyle in that the painting can be read.

His last statement is wonderfully disingenuous; if his picture is successful, simply looking at the characters will tell us what happens next. But Pyle implies that he has given them life; what they do henceforth is of their own volition. He is pretending to act as a journalist, someone who happened to be on the spot and is only recording the facts, as though he's not sure he wants to take credit for immortalizing this gruesome bit of business.

R. T. R.

"Dead Men Tell No Tales," *Collier's Weekly*, December 1899.
Oil on canvas, 21 x 31 ¹/₂", signed lower right.
Courtesy of the Kelly Collection of American Illustration.

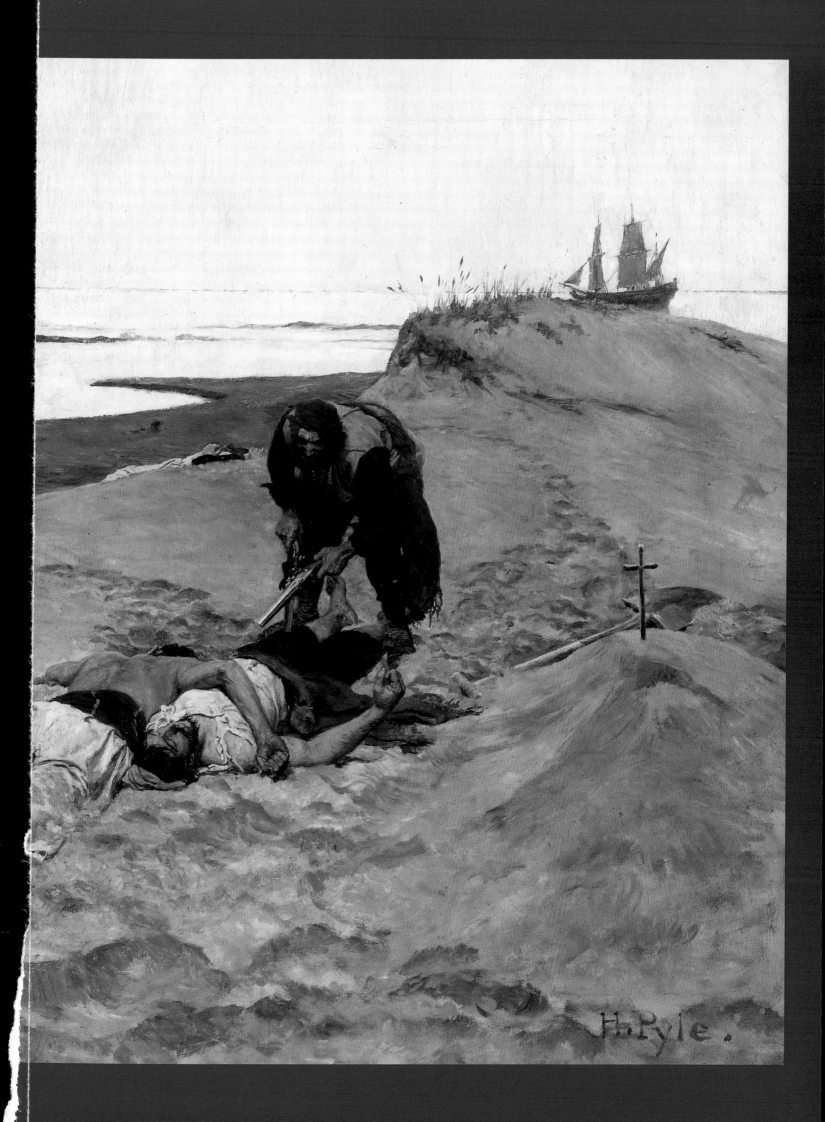

N. C. Wyeth
THE FIGHT IN THE FORETOP

JAMES BOYD WROTE about the American Revolution in his historical romance, *Drums,* which also explored the evolving American character. It was a subject Wyeth shared with enthusiasm. Young colonial American James Frazer begins the story as a dandified youth in London during the Revolution. He receives a message, along with £200 which he is to convey to the American privateer John Paul Jones. He seizes on the opportunity to show his newfound patriotism and joins Jones's ship. At the climactic moment in the story, he is posted in the foretop on the *Bonhomme Richard* in its crucial battle [and famous victory] over the British man-of-war *Serapis.* In an 1897 painting for "Nelson at Trafalgar," an article in *The Century,* Howard Pyle had chosen a similar vantage point in depicting the mizzentop of the battleship, *Redoutable,* from an upward viewpoint, and it no doubt served as an inspiration for Wyeth's picture. In both paintings the diagonals of the rigging were used to dramatic effect in crafting the picture compositions.

All the elements in this painting communicate action and fighting. The figures are small, and the immense masthead and rigging surround the cornered men. The odd angles and cutting diagonals of the ship's rigging suggest the chaos and disorder of the battle. Smoke looms everywhere: close to the viewer in the lower right and around and behind the men. This brings the viewer into the picture plane itself. The profusion of smoke relays the taste and smell of battle. The ripped sail, shattered spars, and bright fire from the cannon communicate the destruction of war. The lack of land or sea in the painting increases the feeling of isolation and further suspends the fighting men in a total environment of battle.

V. M.

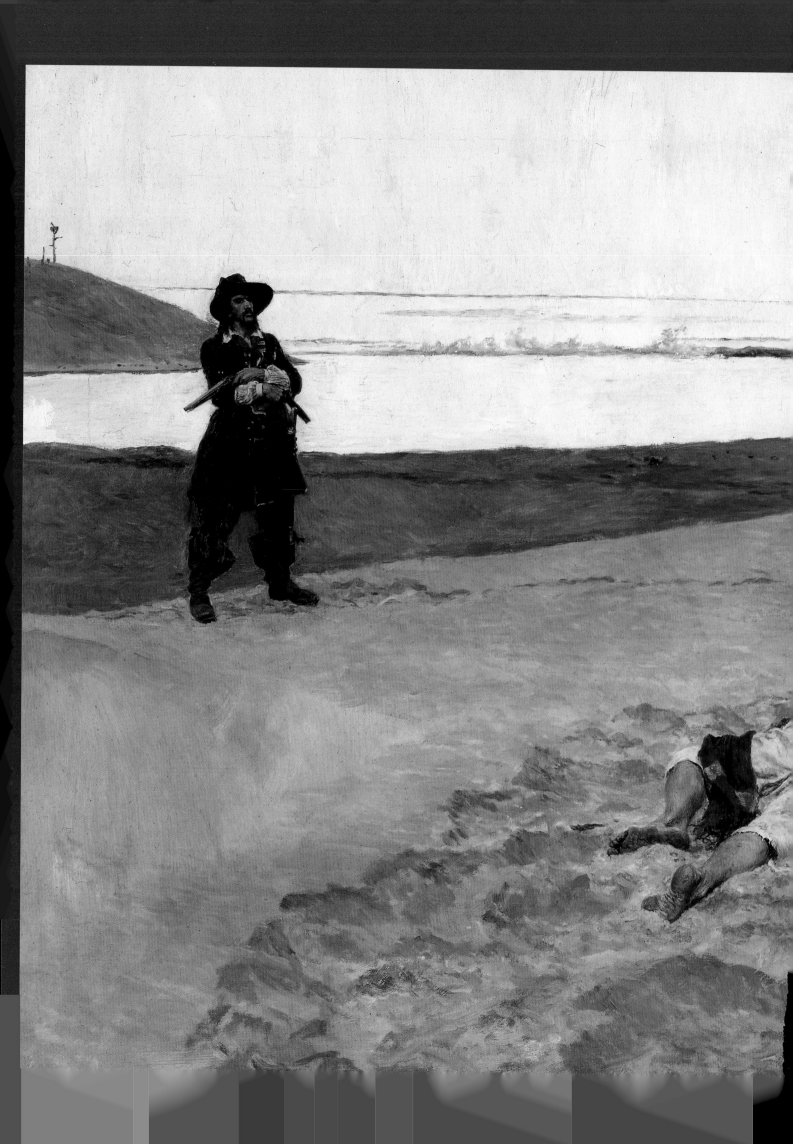

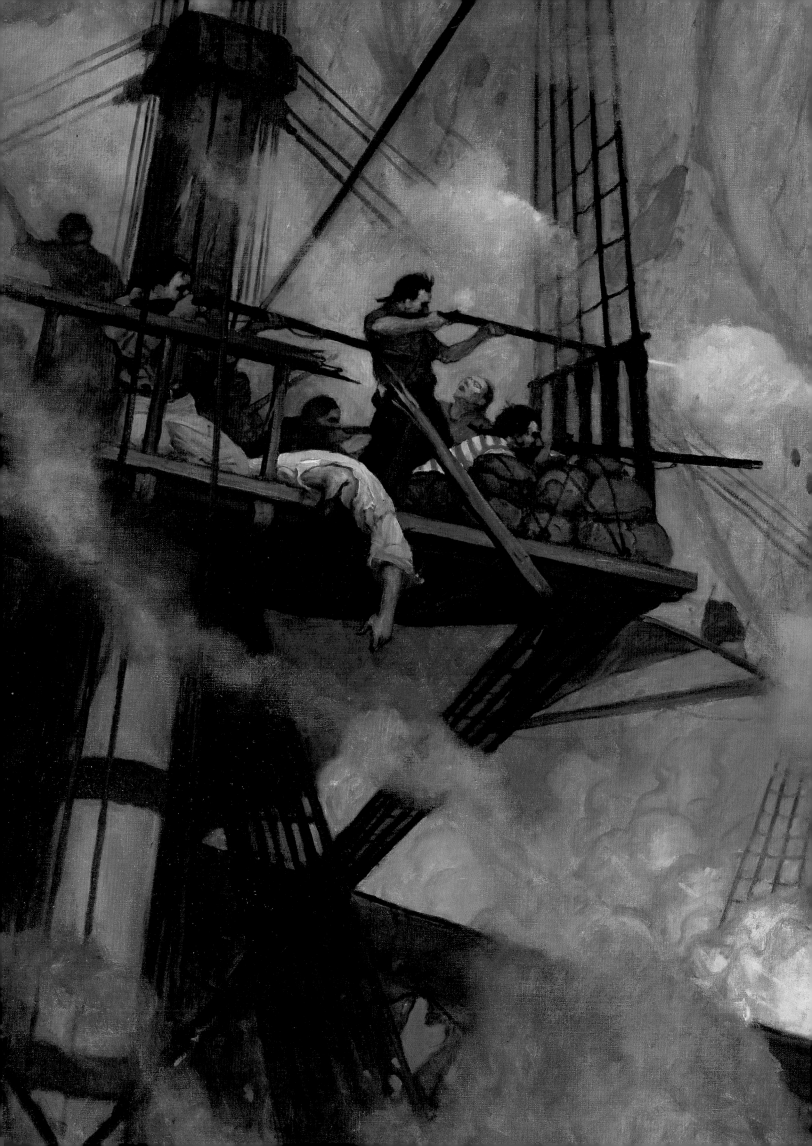

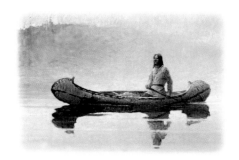

—— THE AMERICAN INDIAN ——

THE INTEREST OF MILLIONS of readers at the turn of the century in the Western Indian-cowboy romanticized adventure was felt by the Eastern public. Hundreds of articles and stories about Indians appeared in newspapers, books, and magazines. These stories were usually accompanied by illustrations.

Since the early nineteenth century, many such tales have perpetuated a stereotype of the Indian in chapbooks, fiction, pulp magazines, paintings, motion pictures, and television. Indians were too often portrayed as scalping savages on the warpath, burning and looting wagon trains and frontier settlements. The artists of the Brandywine School did not support these stereotypes. Devoted to accuracy and sensitive to the spirit and beauty of the Indian way of life, they ranked high among the painters of this subject matter in presenting a more truthful version of their subjects.

American artists played a major part as historians and recorders of the American Indian's life and times. As astute observers, they chronicled in line, brush, and paint the land, people, and animals they encountered. A few understood Indian society thoroughly enough to depict it with authority.

Early in the colonization of America, remarkable documentary drawings of Indian life in Virginia and the region of the Great Lakes were done by the Englishman John White and Charles Becard de Granville, a French-Canadian cartographer. By the 1830s, a growing group of artists pursued their individual view of American Indian life. Following the routes of Lewis and Clark, George Catlin traveled the West for eight years, creating a legacy of Indian portraits. He was followed by a dedicated group of artists that included Karl Bodmer, Seth Eastman, John Mix Stanley, Charles Deas, William Ranney, Alfred Jacob Miller, and Charles Wimar.

Frederic Remington chronicled the last of the Indian wars in the 1880s. His popular paintings of violent action were widely published, immortalizing the Western legend. Late in his career, he convincingly portrayed Indians as he knew them. Other artists such as Charles Russell, Henry Farny, and Joseph Sharp honestly depicted the Plains Indians. By 1890, the Wild West was a memory and the Indians were confined to government reservations.

Two artists, N. C. Wyeth and Frank Schoonover, brought the Pyle philosophy of picture-making to bear on this tradition by painting from the Indians' perspective. From 1904 through 1911, Wyeth focused heavily on frontier scenes and the American Indian. He painted the Navajo and Ute of the Southwest from firsthand experience, and his illustrations of the Iroquois, Mohawk, and Delaware enriched the pages of James Fenimore Cooper's classic books. Perhaps Wyeth's finest interpretations were those of the woodland Indians of the Great Lakes and Northeast. These inhabitants of quiet places were portrayed with dignity and sensitivity, peacefully surrounded by their natural environment. Wyeth's devotion to the principles of Thoreau's philosophy were applied in his own life and art. That love for the human spirit is re-created in his series of canvases for "The Indian in His Solitude" and "The

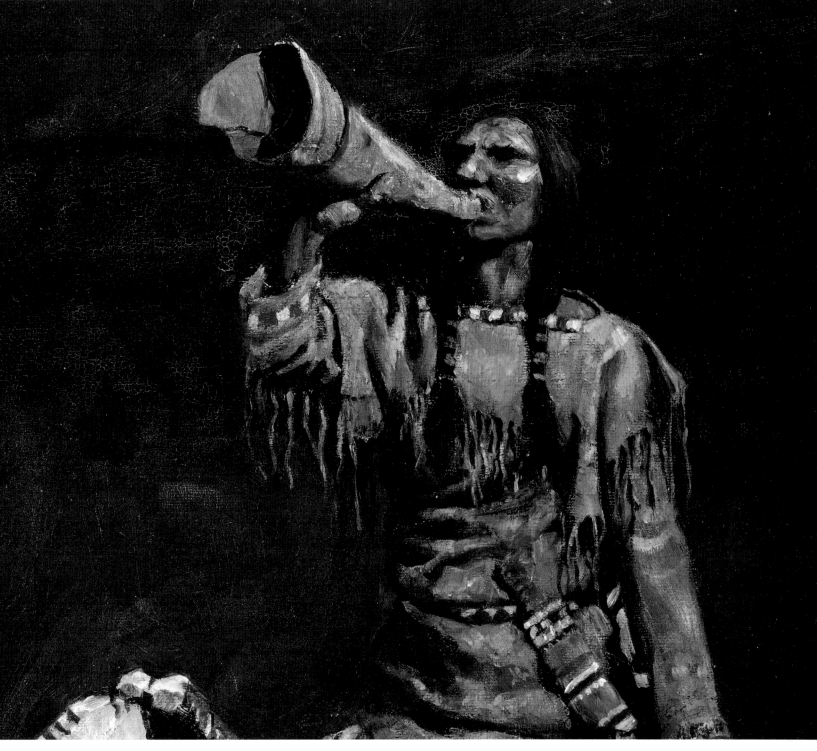

N. C. Wyeth, Illustration for *Scribner's Magazine*, see page 63.

Moods," published as independent paintings in *The Outing Magazine* and *Scribner's*.

Like Wyeth, Frank Schoonover combined his training under Pyle with early direct experience. In the winter of 1903–1904, Frank Schoonover lived in Canada among the Ojibwas, Montagnais, and Cree Indians, traveling over 1,200 miles by dogsled and showshoe in the Hudson Bay and James Bay areas of Quebec and Ontario. Drawing and painting from a canvas tent in sub-zero weather, the artist documented the Indians' struggle for survival, hunting and trapping in the harsh environment. Returning to Canada's Lake Superior wilderness in 1911, Schoonover traveled hundreds of miles by canoe. Following each of these expeditions, articles appeared in *Scribner's* and *Harper's Monthly* magazines, written and illustrated by the artist. Much of Schoonover's early work is devoted to the depiction of the Indians of the subarctic wilderness.

D. A.

Frank E. Schoonover
A NORTHERN MIST

IN THIS TRANQUIL painting, a solitary Indian paddles his birch-bark canoe smoothly through the still water. A veil of mist obscures the land, water, and sky in hues of gray. This is a meditative painting that reveals much of Schoonover's inner spirit. In it we glimpse elements of his lifelong appreciation and love for the outdoors—water, fishing, and canoeing—as well as his deep respect for the Indians and their close kinship to nature.

The image of an Indian in a canoe was a recurring theme for Schoonover. From 1903 to 1968, he portrayed the Indian in many different scenes—paddling in peaceful water, in wild rapids, in mountain streams, in solitude, and even as captive of an imperious scout. It was an image that sparked his imagination over and over, as it did during his Canadian trip in 1911, when he wrote in his diary: "I watched the lake become moonlit and dreamed of how I would put it all on canvas—an Indian in a bark canoe, clear in the full brightness of the moon, in great and noble majesty."

Schoonover painted "A Northern Mist" while working in his Bushkill, Pennsylvania, studio in 1916, just two years after he bought a place of his own there to return to the source of his inspiration—nature. As he explains in an autobiographical letter he wrote in 1958:

> When I was a boy, part of each summer was spent with my grandmother who lived in Bushkill, Pa.... I spent most of the time looking for things. Just little fish and that sort of thing. I built raceways along the bank and I had a lot of waterwheels going.... I also built a flat bottomed boat.... My grandmother wondered about all this and kept asking what I was going to do when I grew up.... I told her... I would do something that would have to do with streams and trees.... I know now that this was the beginning of my making pictures.... I made pen and inks ... woods, streams, bridges, nature, the wilderness—they are all in my work; and the people I painted are as rugged as their environment.

It is evident from this letter that the time Schoonover spent outdoors, playing and exploring in Bushkill at his grandmother's place, continued to inspire him throughout his sixty-eight-year career.

"A Northern Mist" was not painted on commission for an illustration. Schoonover entered it under the title "Solitudes" in a special show and competition among Brandywine artists at the Wilmington Society of Fine Arts. A reviewer for the *International Studio* magazine, December 1916, cited this painting as the strongest work in the show. It was awarded the second prize of $50. [First prize went to N. C. Wyeth.] It was sold immediately to Wilmington mill owner Joseph Bancroft, whose family's art collection was later to become the foundation of the Delaware Art Museum. Schoonover felt strongly about this painting: a special note in his daybook mentioned that all future reproduction rights were to remain within his control.

S. S.

"A Northern Mist," 1916.
Oil on canvas, 31 x 36", signed lower right.

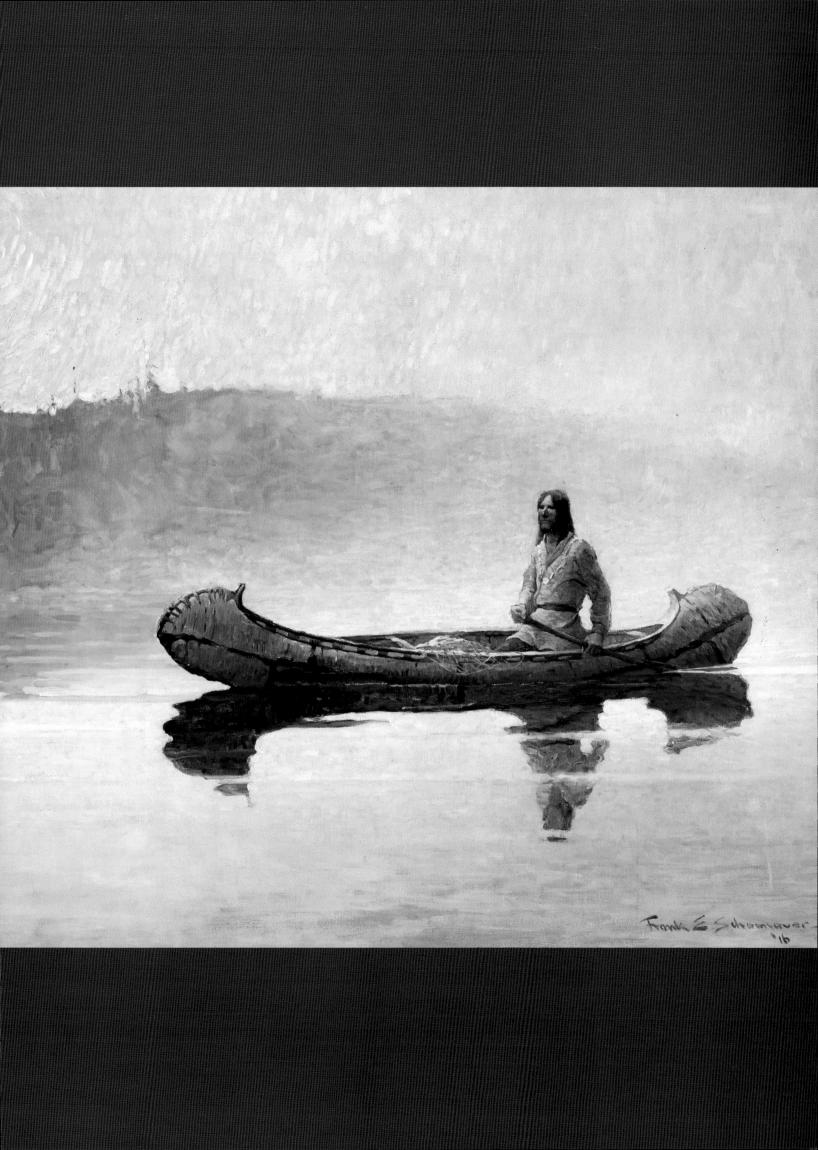

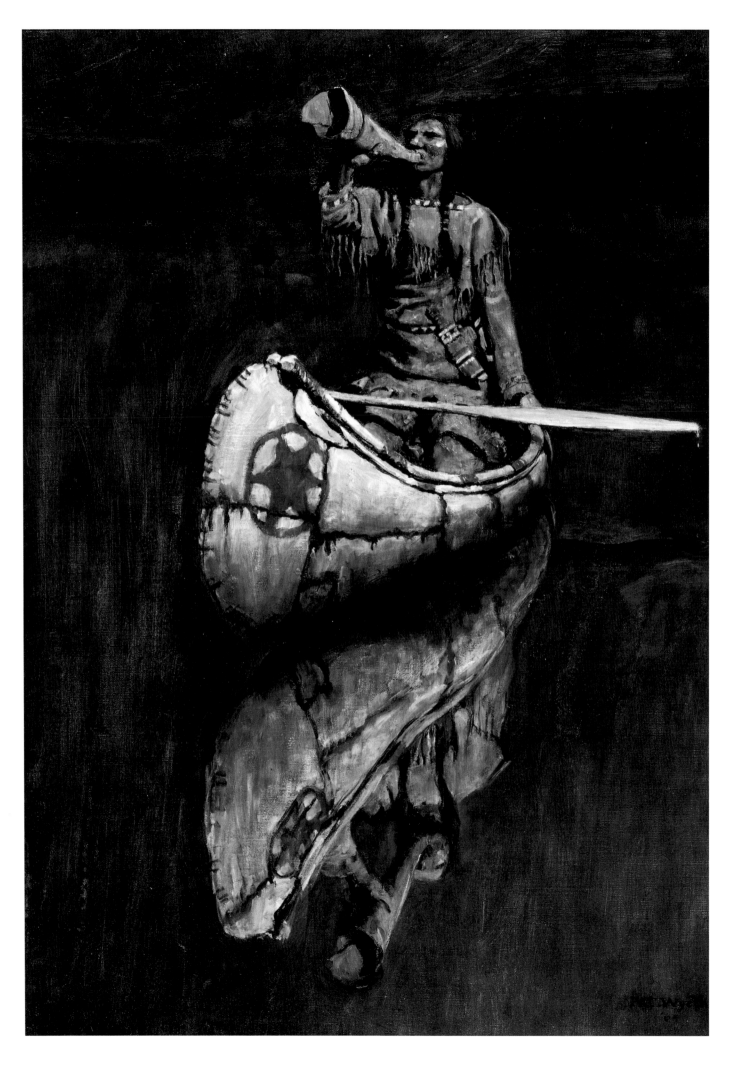

N. C. Wyeth

THE MOOSE CALL

"THE MOOSE CALL" is a composition of bold simplicity, reminiscent of the work of Frederic Remington, whose exhibition had impressed Wyeth on a visit to New York. In this nocturne, a lone Indian silently glides his canoe in the moonlit water of a northern lake. The silence is broken by his call from a birch-bark horn. The moon's pale light softly illuminates the subject. Reflections of the Indian, canoe, and distant shore are enhanced by the glasslike water.

With "The Moose Call," Wyeth established himself as one of a handful of artists who could convincingly portray man in nature. The popularity of this one painting convinced *Scribner's* to issue it as a print, using the high-fidelity gravure process. It was published in three versions: black and white, tinted in sepia, and hand-colored.

N. C. Wyeth himself described the background of this painting:

> In the early summer of 1904, fresh from my studies under Howard Pyle, I made my first sale of a creative painting.
>
> I sought the advice of Howard Pyle as to where it would be best to submit my painting. "Wyeth," he said, "always go to the best publishers first."
>
> The next day found me in the great city of New York facing the small door at number 143 Fifth Avenue, and it was with fear and trembling that I was eventually ushered into the presence of Joseph Chapin, famed art director of Charles Scribner's Sons.
>
> His greeting was quietly pleasant and brief, and he promptly asked to see what I had ardently brought in to show. So I opened the hinged box in which the small painting was fastened and placed it in the most favorable light of that office of the most strange and tangled lighting. He looked at the canvas in silence, tipping his head to right and left in critical consideration. No change of expression; no words. There was an interval of exasperating and unrelated fussing with letters on his desk. My heart sank.
>
> Suddenly and rather tersely, he remarked that he would like to show the painting to Mr. Scribner. In ten minutes he returned, sat down again behind his desk and after a long pause said, "We'll be glad to buy your picture and can offer seventy-five dollars for it. We might run it in one of the fall issues of the magazine."
>
> There is no use in my trying to describe the overwhelming sense of joy, gratitude, and triumph I felt in that moment! Even to this day I can recapture some of the ecstasy of the adventure of that rainy morning in Chapin's office in the old building.

D. A.

"The Moose Call." Illustration for *Scribner's Magazine*,
October 1906, page 480. Oil on canvas, 16 ¼ x 18 ¼",
signed and dated 1904, lower right.

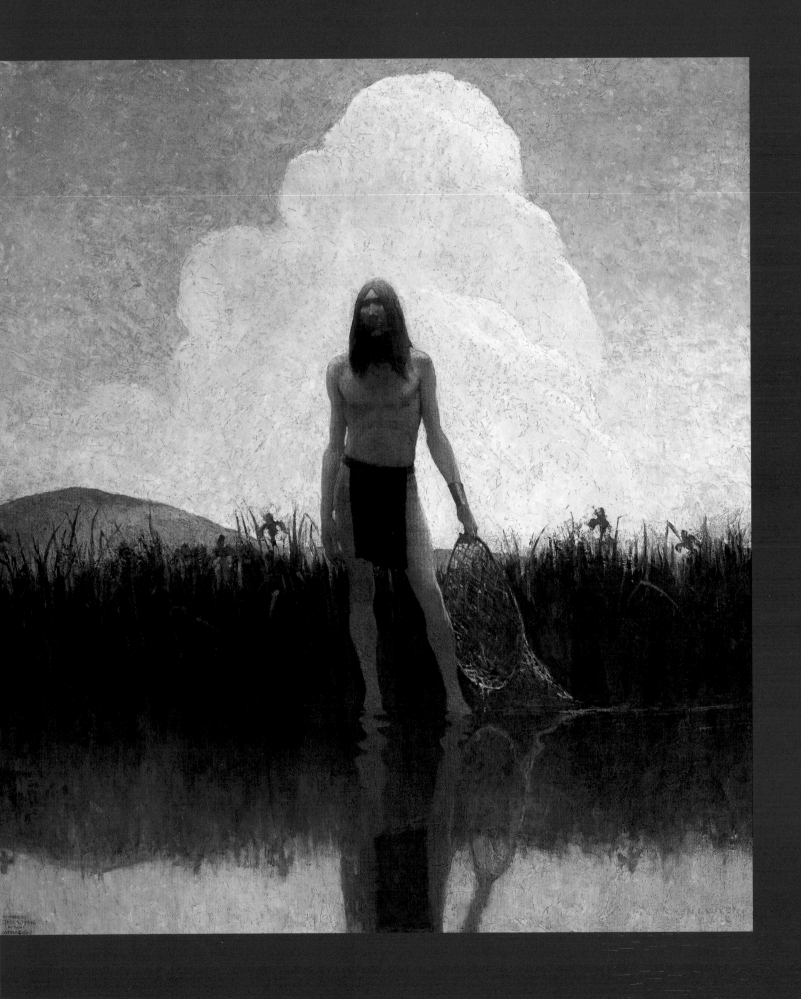

N. C. Wyeth
SUMMER

Hush

Long the mating season's over;

Motionless lie meadow grasses;

Mute the throat of feathered rover;

Mirrored in the still pools' glasses

Hang the hot clouds shimmering fleeces.

Are they runes of summers perished

That the fisher hears—and ceases—

Or the voice of one he cherished?

IN 1909 SCRIBNER's commissioned N. C. Wyeth to paint four canvases to illustrate the four verses of George T. Marsh's poem "The Moods." The paintings were to depict the Native American in intimate spiritual portraits of life, correlating to the progression of the seasons. Within a period of two months, Wyeth completed the group: "Spring [Music]," "Summer [Hush]," "Autumn [Waiting]," and "Winter [Death]." Elated with the results, Wyeth felt he had made a break from illustration and taken a big step forward as a painter. This picture became the basis of a triptych mural painting at the Hotel Utica in Utica, New York, painted in the winter of 1911 and hung by Wyeth in 1912.

In style, this series of paintings could be described as realistic Impressionism. Wyeth's countless hours of plein-air painting are evident in his treatment of spring woods, brooks, rock formations, marsh grasses, clouds, and snow squalls. In technique, the artist combined delicate brushwork, a rich impasto, and a rigorous handling of the palette knife.

In shallow waters an Indian stands transfixed, as if in a dream, gazing across the marsh and into the distance. In his left hand he holds an empty net. Perhaps he waits, like the heron, for a movement or splash. Or is he just caught in thought, flanked by marsh grasses alive with wild iris and reflected on the placid water? Silhouetting the Indian is a great cumulus cloud, which seems to build and shimmer in the atmospheric heat of summer. The composition of "Summer" is strikingly unique and daring for Wyeth. The great cloud is placed to the right of center, as are the Indian's outstretched arm and net. Combined with the light source, these elements move the figure off center and to the right. The figure of the Indian and his reflection are bisected by the marsh grasses, forming the shape of a cross. The stillness is broken by the fishing net, which trails a thin wake of light on the water. Is this a calculated experiment with space for Wyeth? It is certainly a departure from all previous and, to my knowledge, later works.

D. A.

Illustration for "Hush" by George T. Marsh, New York: Charles Scribner's Sons, 1909, p. 682.

Oil on canvas, 29 ¼ x 33", inscribed to Clara and Edwin on their wedding day,

December 25, 1913, signed lower left.

N. C. Wyeth
THE MAGIC POOL

From his pouch he took his colors,

Took his paints of different colors,

On the smooth bark of a birch-tree

Painted many shapes and figures,

Wonderful and mystic figures,

And each figure had a meaning,

Each some work or thought suggested.

THIS VERSE FROM Henry Wadsworth Longfellow's *The Song of Hiawatha* mirrors the artist-illustrator N. C. Wyeth's loving depiction of the Native American.

"The Magic Pool" is one of five paintings from the legend of Hiawatha that made up Wyeth's series entitled "The Indian in His Solitude." This canvas was painted in the spring of 1906. In the composition, a velvety pool of dark water leads one's eye to an Indian lying chest down and drinking. Tension in the shoulders and arms supports his weight, and his hands grip the slippery moss-covered rocks. A subtle reflection of the Indian is broken by the circular rings of water as he drinks. Wyeth used a palette of close values to achieve this visually poetic effect.

Collectively, "The Indian in His Solitude" represents Wyeth at his best. He interpreted the woodland Indian of eastern North America with great feeling and sincerity. In conjunction with the painting's publication in *The Outing* for June 1907, Outing Publishing Company published a boxed set of five mounted prints.

Note: One of the paintings, titled "The Hunter," was originally commissioned as a cover for *McClure's Magazine* by Howard Pyle during his stint there as art editor. After Pyle left, and since *McClure's* had no plans to reproduce the painting, Wyeth withdrew it from them, and it subsequently became part of *The Outing*'s "Solitude" series.

D. A.

"Unktahee, the God of Water." Illustration for *The Outing Magazine*,
June 1907. Oil on canvas, 25 ¼ x 37 ¼",
signed and dated lower right.

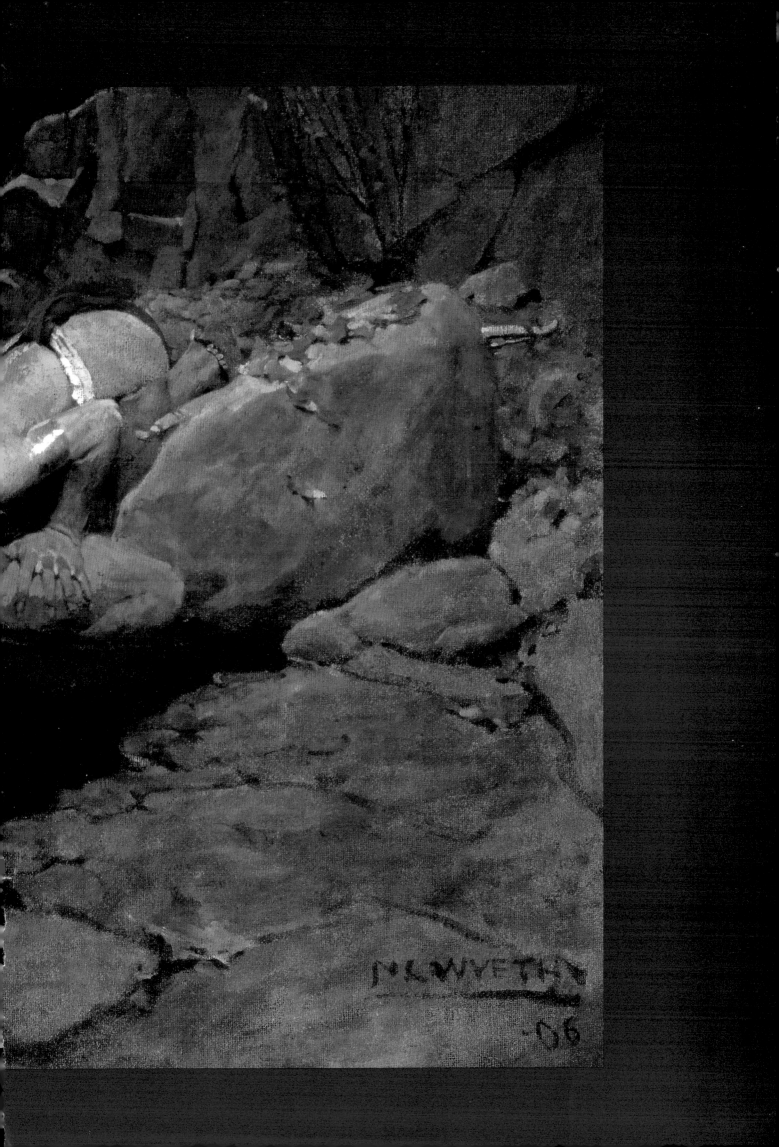

N. C. Wyeth
INDIAN LANCE

N. C. WYETH BELIEVED "for an artist to draw virile pictures, one must live virilely."

He justified these beliefs when, in 1904, he accepted an assignment from *Scribner's* to visit and depict the still wild and unsettled Southwest. During this trip, he made many successful illustrations as well as many sketches.

Wyeth's work was so popular that, in 1906, he again traveled west on a commission for *The Outing*. While in Colorado, he lived and worked as a cowboy so that he would be better able to accurately paint this way of life. His illustrated article "A Day with the Round Up" was an immediate success, and for almost two decades Wyeth was besieged by publishers who wanted him to continue painting the Old West.

The painting "Indian Lance," done in 1909, may have been used for the dust jacket of *Beyond the Old Frontier* [1913] by George Bird Grinnell. It definitely appeared as a cover for *The American Boy* magazine in September 1921. Painted in a vignette design, the picture focuses the viewer's attention on the horse and rider. The viewer can instantly feel the motion of that majestic horse, which is ridden by a warrior chief, resplendent in his war bonnet. The viewer can also feel the impending pursuit and relate to the sympathetic portrayal of the Native American.

Artistically, the painting is a masterpiece in its simplicity of design. Wyeth's use of shadow and his emphasis on the cloud of dust maximize the motion of the subject.

In the bold application of the paint, one can see that Wyeth created his spontaneous style by using a fat brush with plenty of oils. The colors are mostly earth tones, but they are not muddy, and the highlights give the needed contrast to make the horse and rider three-dimensional.

M. F. & J. A.

Cover illustration for *The American Boy* magazine, September 1921.
Reprinted in N. C. Wyeth's *Wild West*, Brandywine River Museum. Edited by Catherine E. Hutchins, Chadds Ford: Brandywine Conservancy, Inc., 1990. Essay by Géné E. Harris [page 21]. Oil on canvas, 29 ¼ x 24 ¼", signed.

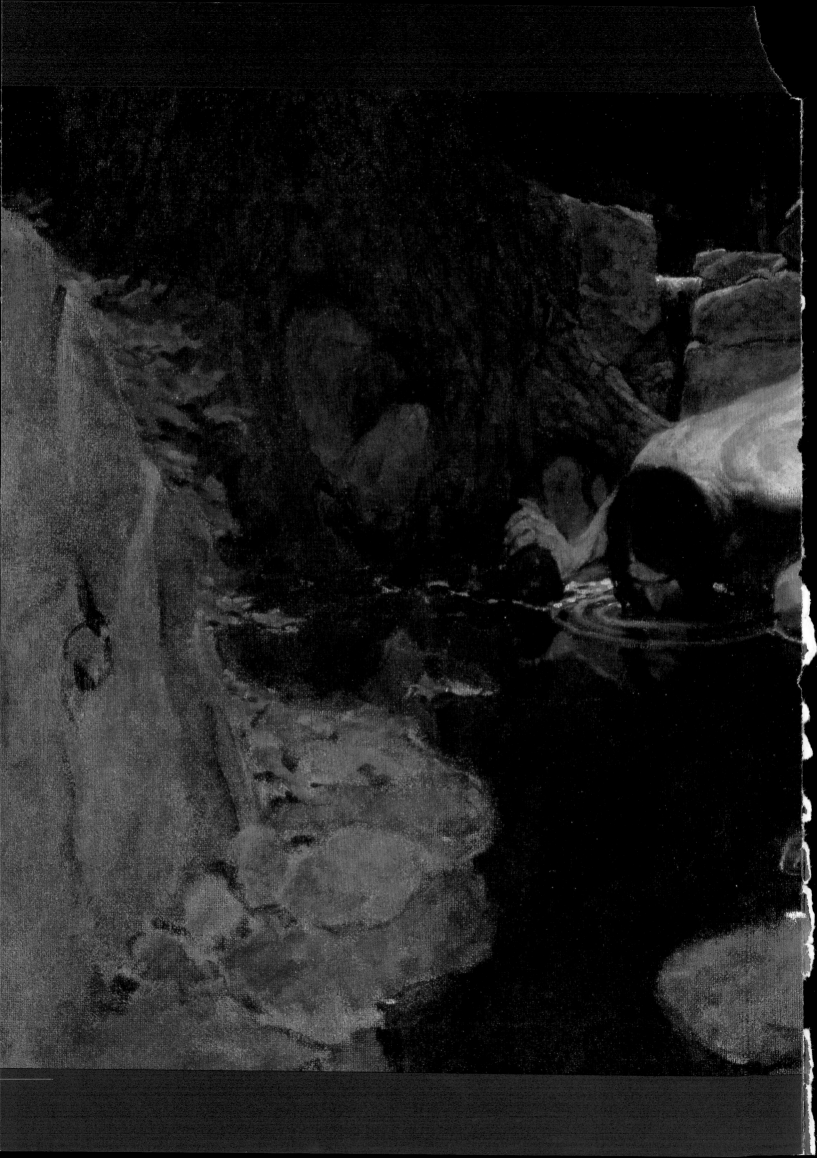

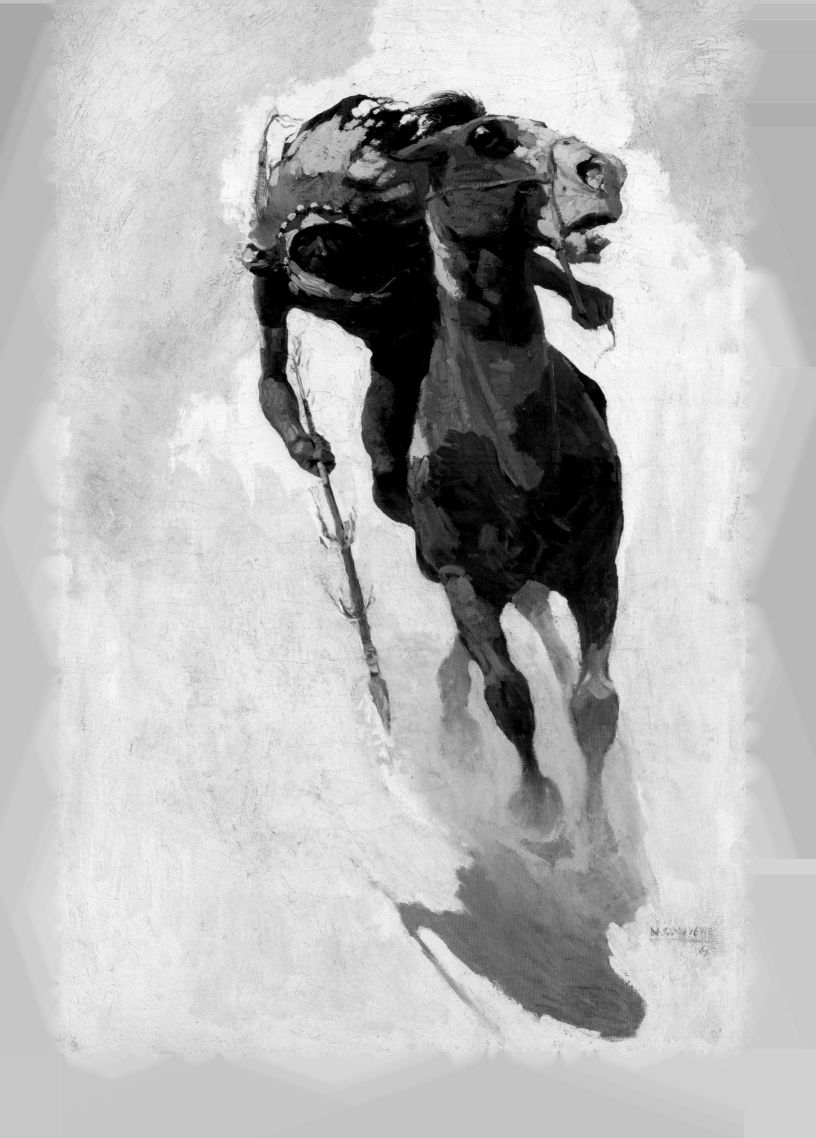

N. C. Wyeth
THE LAST OF THE MOHICANS

THE LAST OF THE MOHICANS, by James Fenimore Cooper, is the first "classic" by an American author that N. C. Wyeth illustrated for Scribner's. Cooper was America's first significant novelist. Wyeth was thrilled to be commissioned to illustrate this saga, which takes place in the wilderness of eighteenth-century upstate New York, at a time when it was still the frontier. Against this historical backdrop, two civilizations are engaged in a battle for the continent.

Extensive research, study of the novel, and trips to the Adirondacks consumed so much of Wyeth's time that he was forced to complete the set of thirteen illustrations for the book in only about six weeks. Wyeth's creative output flourished under the pressure, and he produced an extraordinary series of paintings. While he was pleased with the results, he was also bitterly disappointed with the engravers' color plates. They did not resemble the original canvases.

For the first time, Wyeth openly complained about the failure of reproduction printing methods. One can understand his immense frustration, because the technical process of reproduction did not measure up to the ability of the artists. The originally published plate "In the Council Lodge" does not compare with the vibrancy of the original painting. Wyeth may have been more sensitive to this failure because, in 1916, prior to illustrating *The Last of the Mohicans,* he wrote to his close friend and fellow painter Sidney Chase about a new direction in his painting that greatly enhanced the brilliance of his colors.

This use of pure, unmixed color is particularly apparent in the series of illustrations from *The Last of the Mohicans.* Wyeth's direct application of pure color is seen in the foreground and the blankets. The vibrancy of the color itself suggests the leadership and hierarchy within the tribunal. The chief is wearing the powerful color of red, and subordinate counselors wear blue and green.

In this picture, newly reproduced from the original painting, Wyeth used color to effectively communicate the crucial moment when Hawkeye enters camp. For a setting, he selected the dark, somber Huron lodge interior. The chief and several of his advisers and warriors are poised, deep in the decision-making process. Silence reigns, but the atmosphere is charged with electricity. The brilliant colors of the Indians' blankets surrounded by the austere color of the interior emotionally highlight the intensity of the mood. The implacable expressions in the faces are lit and detailed just enough behind the war paint to show the tension and the gravity of the situation.

V.M.

"A flaring torch was burning in the play, and sent its red glare from face to face and figure to figure, as it waved in the currents of the air."
Illustration for *The Last of the Mohicans* by James Fenimore Cooper, New York: Charles Scribner's Sons
[A Scribner's Illustrated Classic], 1919. Oil on canvas, 39 ¼ x 31 ¼", signed lower left.

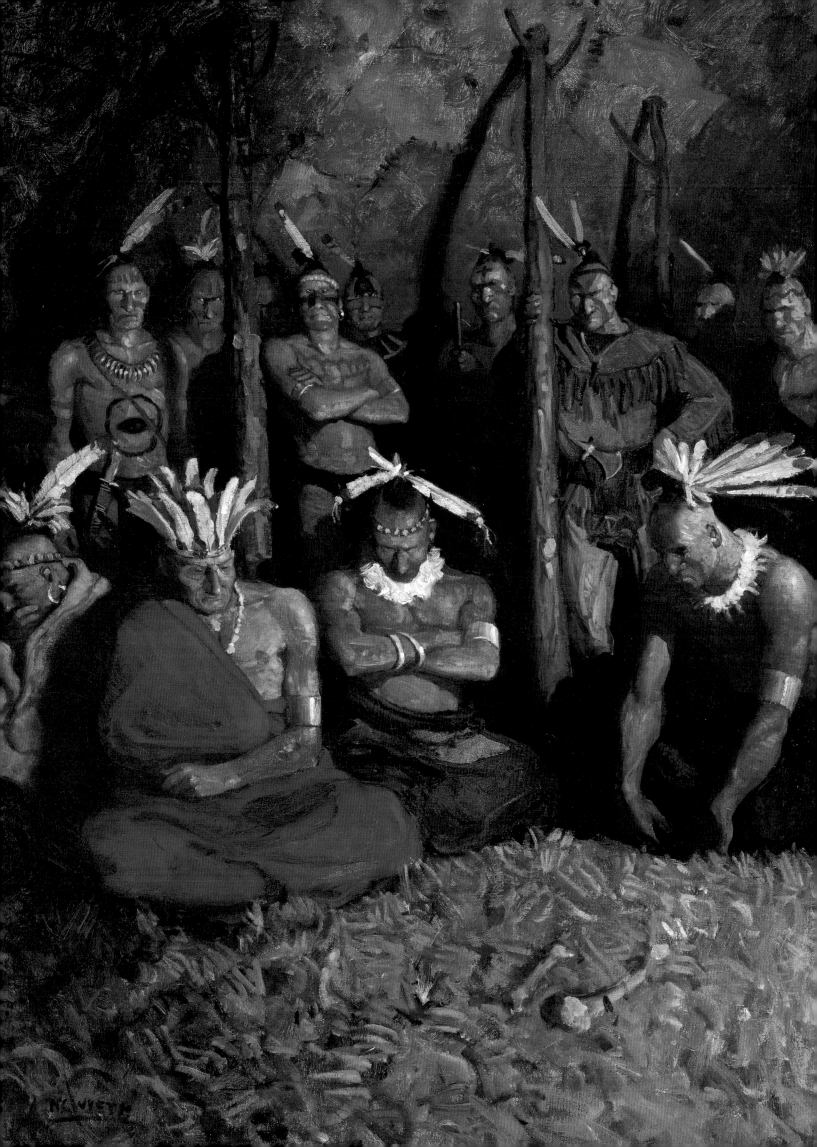

——— THE FRONTIER ———

To THE ARTISTS recording it, life on the frontier was primarily a matter of observing the events around them. They were reporters rather than historians, with no special insight into the future. Artists were attracted to the newness of the land and the customs and dress of the Native Americans. They were also interested in the Indians' changing society as it took shape along the outreaching settlements and new territories.

We now think of the frontier as the Old West. It was the last unexplored area of the country, and the process of settling it extended over a long period of time. The Eastern populace had an immense appetite for information about the West. Newspapers and magazines paid correspondents to cover events as they occurred—from the discovery of gold in California to the exploits of Jesse James and the land rush in the Oklahoma territory. Writers, such as Bret Harte, Owen Wister, and Mark Twain, wrote bestselling novels that capitalized on the popular fascination with the "Wild" West. There was a corresponding demand for fine illustrators.

Much of the early exploration and settlement of the country was recorded by artists such as George Catlin, Alfred Jacob Miller, and Karl Bodmer. They accompanied expeditions into the frontier west of the Mississippi and were able to picture the Indians in their native habitat—as yet untouched by European civilization. Other artists such as Albert Bierstadt and Thomas Moran painted the grandeur of the Western terrain.

Frederic Remington recognized the imminent disappearance of the Old West and recorded it in much of his work. Charles Russell lived with the Indians long enough to empathize with their plight and to paint a sympathetic record of their lifestyle.

N. C. Wyeth, who followed these artists, still saw enough of the vanishing West to absorb authentic material and incorporate it in his illustrations. He took part in a cattle roundup and followed a sheep drive with the Navajos. Harvey Dunn, the son of a homesteading family in South Dakota, lived through the hardships of blizzard and drought. To earn money to go to art school, he plowed the virgin sod of buffalo grass. Philip Goodwin recorded the end of unlimited big-game hunting, featuring the animals and the adventurous sportsmen in the wilderness. Frank Schoonover lived as a trapper with the Indians in the Hudson Bay area, making his way through the trackless country and learning to survive alone. His many drawings from that period provided authentic information for his later illustrations.

There is yet another category of picture-making, work done by artists who came along after the events. Many of these artists, with the benefit of hindsight, have been able to reconstruct events more effectively than some artists who witnessed them.

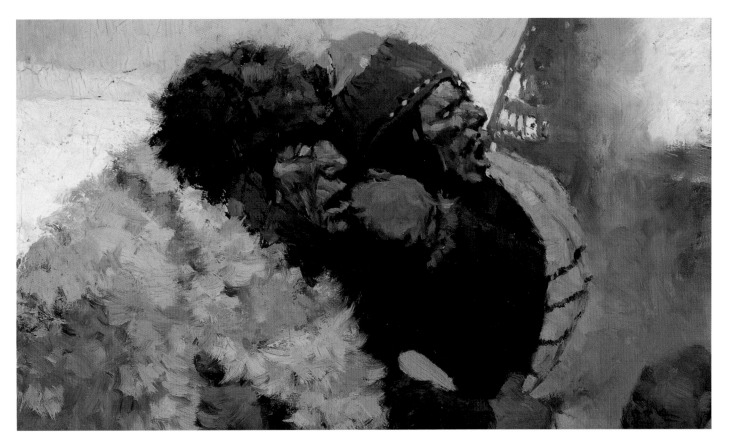

Frank E. Schoonover, Illustration for "Only Jules Verbaux, A Story of the Far Northwest" see page 82.

There was always a time lag between an event and its depiction. The most facile artist could make only hurried sketches of a buffalo hunt or the Oklahoma land rush. The artist needed to go to his studio afterward and compose the picture from a combination of memory, sketches, artifacts, costumes, models, etc. Sometimes months or years might have intervened before the picture was completed. This is where Pyle excelled: in the painting of historical subjects. When Woodrow Wilson's monumental five-volume *History of the American People* was completed in 1902, it was first published in monthly installments in *Harper's Monthly* magazine. Howard Pyle, who was at the height of his professional career at that time, did some of his finest artwork for the book, covering every stage of the exploration of the frontier, the growth of the colonies, and the events of the American Revolution. Involvement with history became a lifelong preoccupation for Pyle, and he made himself an authority on everything he depicted—from the number of buttons on a British officer's dress uniform to the drill exercises of the newly recruited rebel troops.

In one of his Monday night lectures to his students Pyle explained, "Colonial life appeals so strongly to me that to come across things that have been handed down from that time fills me with a feeling akin to homesickness—so that merely to pick up a fragment of that period is all that is necessary to bring before me that quaint life. My friends tell me that my pictures look as though I had lived in that time."

The extent of his artistic and emotional involvement with the colonial period gave Pyle the authority to paint pictures with the expertise of a contemporary. We trust his authenticity and his interpretation of the spirit of the times. We also can be grateful to him and his students for giving us a vivid portrayal of an era when most of America was a frontier. Pyle taught historical accuracy and inspired his students to enrich it with their own firsthand experience of the frontier. The paintings in this section show Pyle's students at their finest, capturing the spirit of adventure combined with accurate details.

W. R.

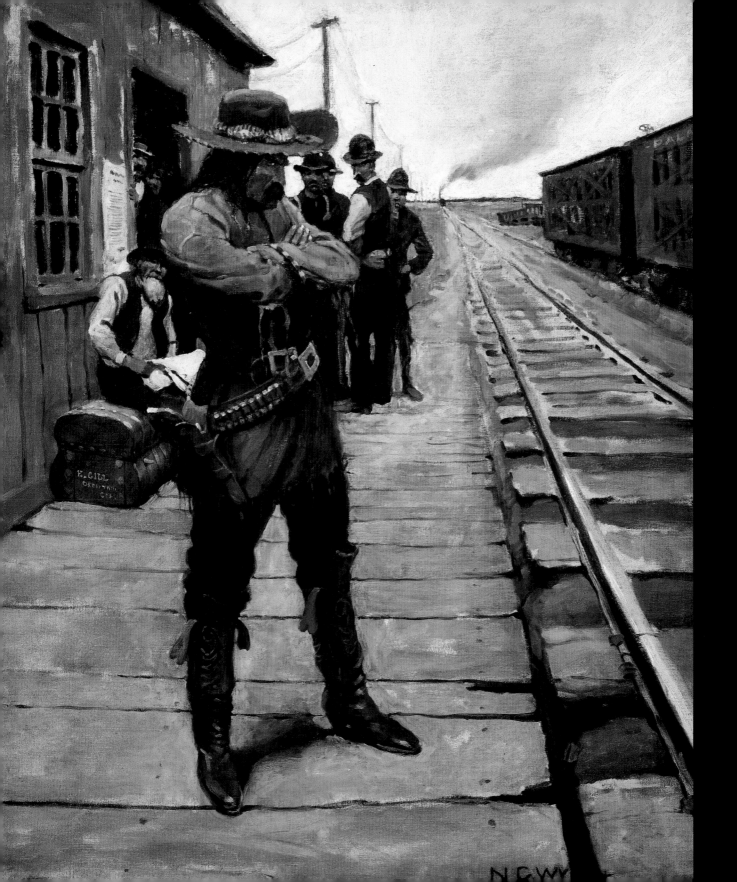

N. C. Wyeth
Hungry but Stern on the Depot Platform

In September 1904, N. C. Wyeth embarked on a trip to the Western United States to explore firsthand the magnificent and adventurous West of his imagination. Urged by his mentor, Howard Pyle, to experience life before attempting to paint it, Wyeth excitedly ventured west to gather directly the visual images and physical experience to give his work vitality. *The Saturday Evening Post,* which had helped finance this trip, hired Wyeth to illustrate three stories by Emerson Hough, one of which was "The Imitation Bad Man, a Chronicle of Long Hair and Short Nerve," published January 20, 1906. "Hungry but Stern on the Depot Platform" appeared as the last of four black-and-white illustrations in the story.

This picture calls to mind some of Wyeth's real-life experiences of facing hunger and stern reality in the West. After a fifty-four-hour train ride through the Great Plains to Denver, Wyeth participated in a roundup for nine days. He was in the saddle from 5:30 A.M. to dusk, observing "horse pitching and bucking" according to one of his letters. Later, he became a cowpuncher for the "Hash Knife" outfit. He intended at first to sketch only as a guest, but eventually he felt compelled to actively join in the work. His trip continued from Colorado to the Navajo reservation, where he sketched Indians and hogans. In the midst of his many adventures, Mexicans raided Muddy Springs Post, stealing $500, including $85 from Wyeth. He enthusiastically joined a manhunt for several days, hoping to capture the thieves, but the posse proved unsuccessful. To earn money, he was forced to take a job as a mail carrier between Fort Defiance, Arizona, and Reitz's Trading Post [Two Gray Hills] in New Mexico. The lonely trip took three days and covered one hundred miles over rugged terrain in the cold blowing sand and snow of a Southwestern November.

N. C. Wyeth recognized the value of these real-life adventures, because they later enabled him to paint fictional pictures such as "Hungry but Stern" with accurate detail, costumes, body language, and attitude. The memories and actual props, such as Indian blankets, clothing, and cowboy paraphernalia, gave Wyeth enough information to supply his publishers with illustrations for years. They made him one of the most sought-after and popular Western illustrators of his time.

V. M.

Illustration for "The Imitation Badman" by Emerson Hough,
The Saturday Evening Post, January 20, 1906.
Oil on canvas, 30 x 26", signed lower right.

Harvey Dunn
THE FIRING SQUAD

THIS COMPOSITION EXEMPLIFIES an admonition Dunn made to his own students. When reading a manuscript, he said, they should always choose to paint the "epic" rather than the "incident," and look for a universal theme underlying the story that would sum up its message, whether expressed in words or not. If necessary, they could paint something of their own, complementary to the story, something that happened beforehand or afterward, to give substance to an otherwise shallow text.

Here the author, George Pattulo, with whom Dunn collaborated on several stories for *The Saturday Evening Post*, provided an excellent dramatic base for an important picture. In this depiction of a prisoner facing a Mexican firing squad, Dunn has created a powerful tension between the raw emotions of fear and brutality. The blue door separates the prisoner from the Mexican officer who is about to give the order to fire, yet it also draws the viewer's eye to the two flanking figures. At the right, the terrified woman heightens the drama. The rough, cobbled street and adobe building contribute to the harsh environment. The torn wall alongside the prisoner indicates past executions, and the vultures gathered on the rooftops presage the one to come. Although painted from a panoramic viewpoint, all the visual elements have been chosen with great care, and each one contributes to the overriding theme of life or death.

At the same time, Dunn gives the author his due. A lesser artist might have chosen the moment when the rifles are fired or shown a last-minute reprieve that saves the defiant prisoner. This would have robbed the story of much of its suspense, and the potential reader might have lost interest. Thus a good writer and a good illustrator can work in tandem, each complementing the other yet retaining his own identity. This story can be read without the illustration; the picture, too, stands alone as an independent painting.

W. R.

"A wild scream made me jump and I saw the rifles waver."
Illustration for "The Wrong Road" by George Pattulo, *The Saturday Evening Post*, January 6, 1917.
Oil on canvas, 30 x 40", signed and dated 1916.

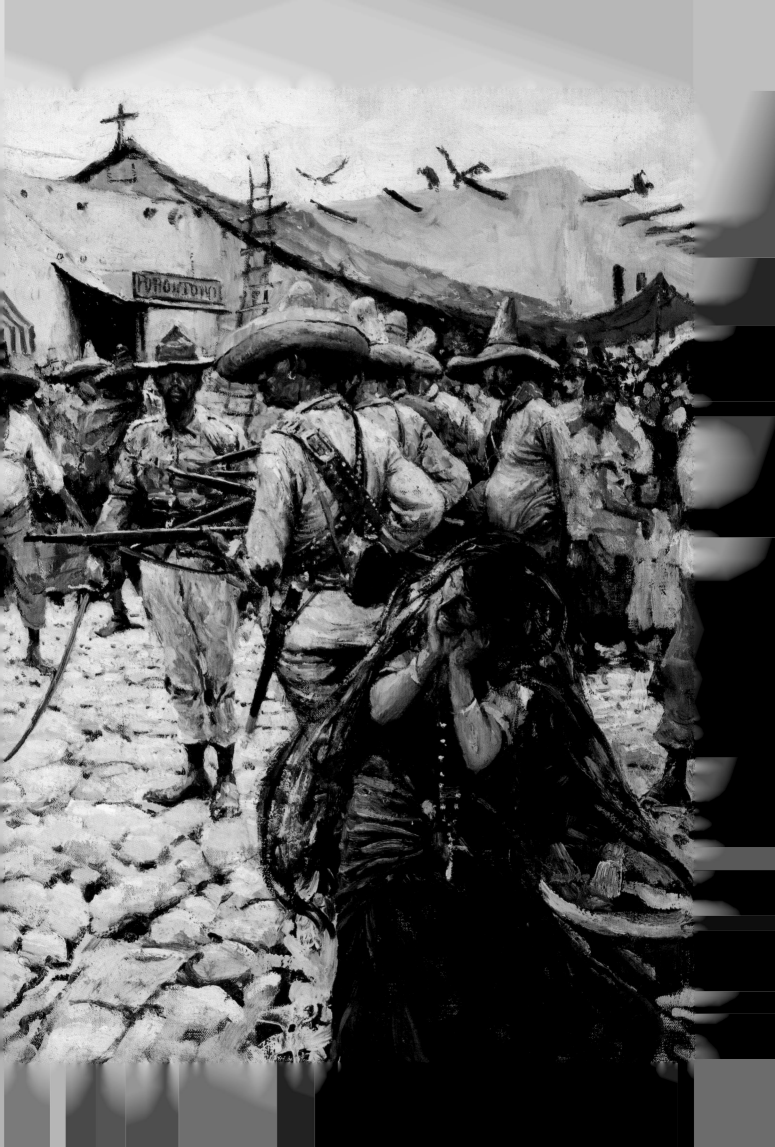

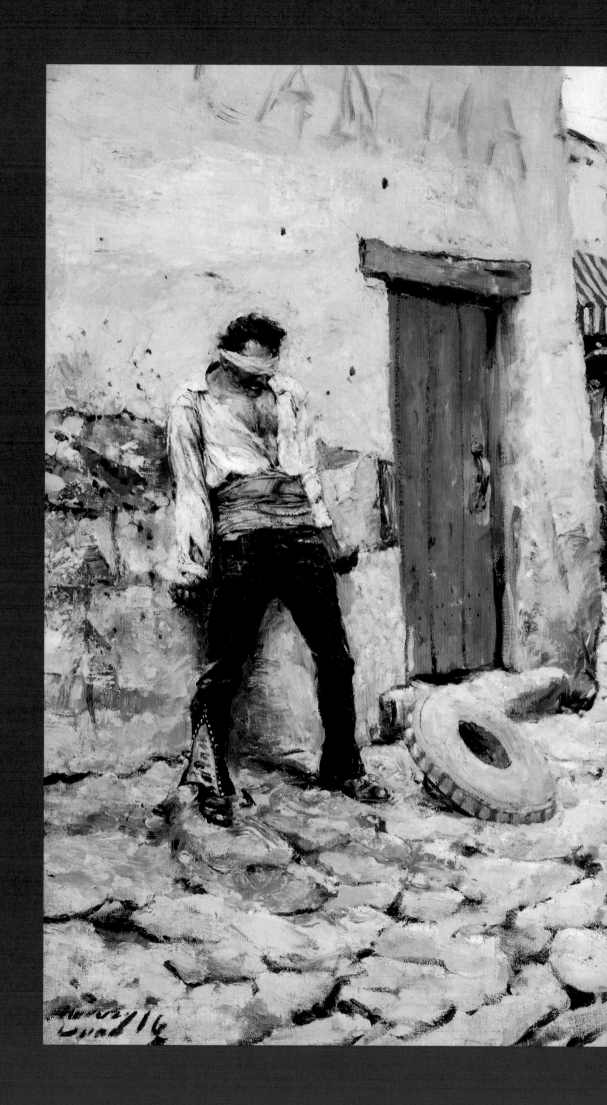

Frank E. Schoonover
SUDDENLY . . . A FIGURE STOOD BEFORE THEM

IN THE WINTER of 1903–1904, Frank Schoonover made an extraordinary journey into northern Quebec and Ontario, crossing the Hudson Bay by snowshoe and dogsled with two Indian guides. True to Howard Pyle's teaching, he experienced firsthand the Canadian wilderness, and it became one of his prime areas of expertise in illustration.

In 1905, *Scribner's* magazine published two stories, both written and illustrated by Schoonover, about his trip to Canada: "The Edge of the Wilderness" and "Winter Harvesters." These were followed by illustrations for a long series of Canadian frontier stories written by Lawrence Mott, including "Jules of the Great Heart," for *The Century*.

This painting, from "Only Jules Verbaux," part of the "Jules of the Great Heart" series, depicts three Indian trappers lost in a fierce snowstorm for four days. They are desperate from lack of food and numb from the intense cold. Fighting for survival, they are bundled in furs and hides and huddled in a close circle around a feeble fire, attempting to shield themselves from the wind by propping up the dogsled. Even the dog, crouching low in the foreground, his fur ruffled and frozen, is struggling to stay warm.

Schoonover draws your attention directly to the three central figures in the painting with his characteristic accent of cadmium red in their hats, scarves, and gloves. Conversely, he makes the fire in the center small and barely visible, but the smoke that rises from it points to where the stranger is standing. He appears to have come from nowhere, blending with the frigid gray and white surroundings. The trappers are portrayed at the point in the story when they have already given up hope. They gape at their savior in utter disbelief, as if he had risen from the smoke of the fire they have been desperately trying to keep aflame.

It was in the years immediately following his graduation from Howard Pyle's school in 1900 that Schoonover painted what many consider to be his best illustrations, including "Only Jules Verbaux," which is certainly one of his masterpieces. Applying impressionistic dabs of half-mixed color to the canvas, he intensifies the frigid feeling of the environment in which the story is set. Schoonover also employs what Pyle called "mental projection" to portray this scene. He could draw from his own firsthand experience, to depict the rigors of snowshoeing through heavy snow, the daily hardships of making camp in sub-zero temperatures and the laborious job the men and dogs had breaking trail. The details in the clothing, the furs, the blankets, and the snowshoes all lend authenticity to this illustration. Schoonover's sure but quick, unstudied strokes evoke a plein-air feel, further enhancing the illusion that we are on the spot or in the scene.

S. S.

"When suddenly without a sound of any kind a figure stood before them."
Illustration for "Only Jules Verbaux, A Story of the Far Northwest" by Lawrence Mott, *The Century Magazine*, 1905.
Oil on canvas, 30 x 20", signed lower left.

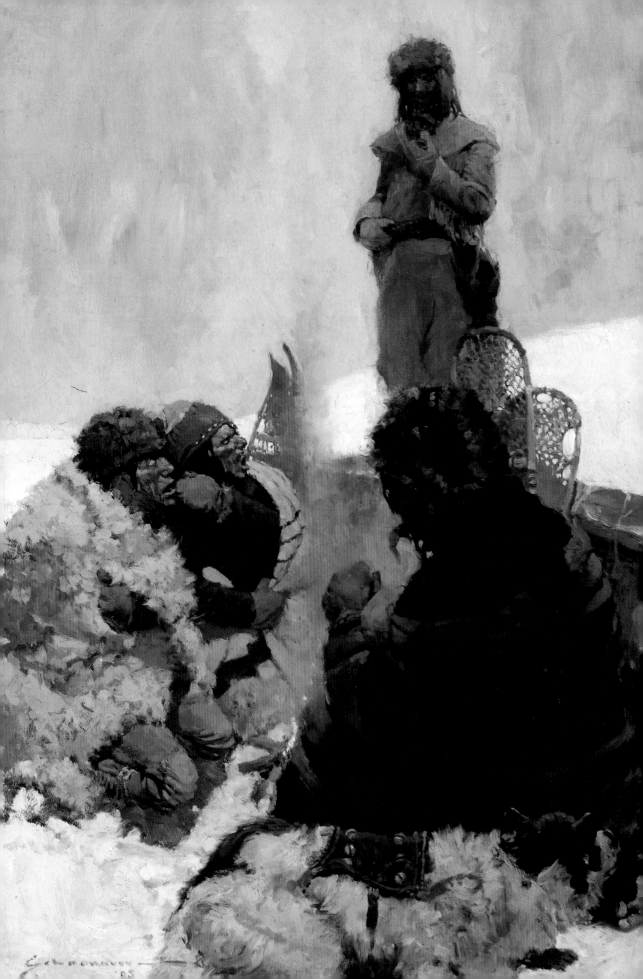

N. C. Wyeth
The Ledge

In January of 1906, *The Outing Magazine* sponsored N. C. Wyeth on a trip to Grand County, Colorado, to observe mining engineering. One result was a series of four illustrations in color for a story by W. M. Raine and W. H. Eader titled "How They Opened the Snow Road," published by *The Outing* the following January. Wyeth responded to this assignment with an enormous canvas. The careful execution clearly shows his drive to make serious paintings even while accepting commissions for illustrations.

This painting, captioned "Long Henry drove cautiously across the scene of yesterday's accident and up the approach to the rocky point," depicts the perilous conditions in crossing the snowbound roads of the mountainous West. The steep angle of the wagon, poised against the precipitous drop of the mountains, draws our attention to the extreme hardships these miners endured. The wagon looms enormous in comparison to the smaller scale of the horses, emphasizing the adversity and the arduous task the four-horse team faced in order to pull the heavy weight on the runners. By placing the imposing figures of the man, horse team, and wagon in the center of the painting, Wyeth dramatizes their struggle, but he also shows that they are dwarfed by the scale of the huge mountains. Wyeth painted a rapidly diminishing perspective to the narrow trail, using a high vertical plane to further accentuate the steep climb, the narrowness of the ledge, and the dangerous drop below. We wonder if this wagon will survive the next curve.

Pyle taught Wyeth to "paint the air" in order to transmit the subtleties of feeling and mood into a painting. The surrounding scenery of stark cliffs and deep, white snow creates the atmosphere of sub-freezing temperature. The sun shines on the distant peaks, but not on this passage where man makes a heroic gesture by driving across the Western mountains. Wyeth's belief in the immanent power of nature seems to be the real subject of this early painting.

V. M.

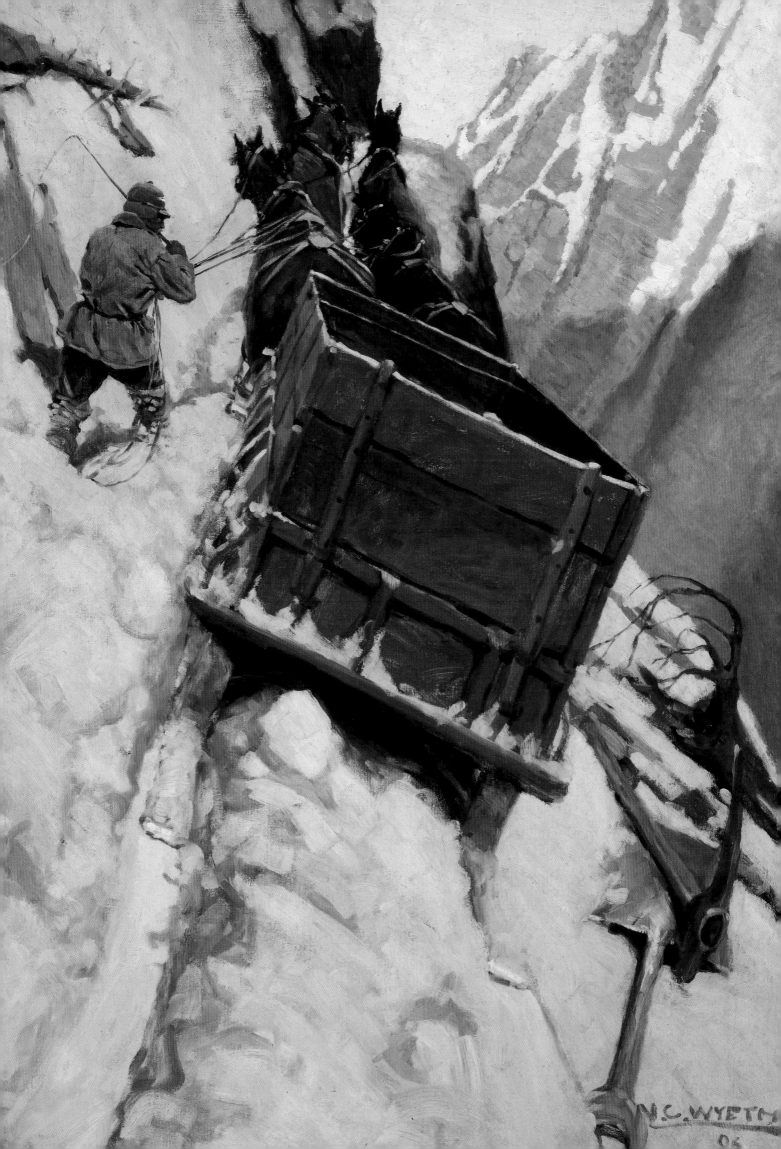

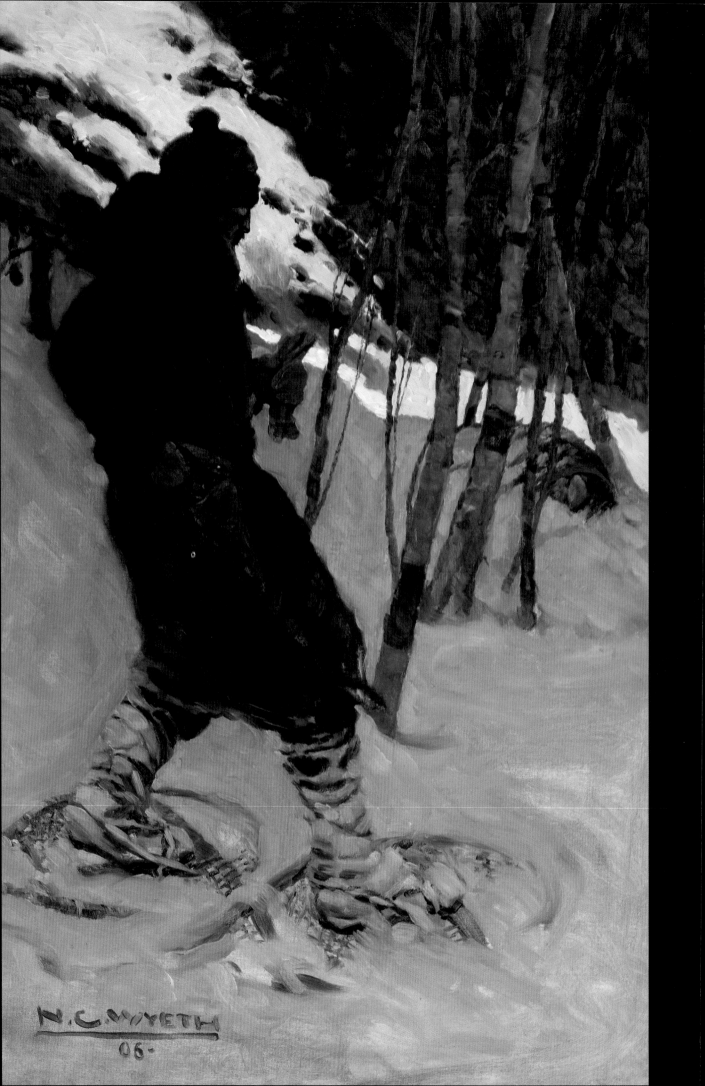

N. C. Wyeth
RESCUE IN THE SNOW

IN NOVEMBER 1906, *The Outing* published this N. C. Wyeth painting as the frontispiece for a story by Lawrence Mott entitled "Love in the Wilderness." Mott wrote a romantic tale about Chictou Bernard, a French Canadian trapper accused of poaching on "company lands" and saved from the pursuing police by his devoted girlfriend, Narron. Refusing to betray her lover, Narron bravely creates a false trail by using Bernard's snowshoes and leads Clyde, the English policeman, on a diversionary hunt. When he relinquishes the chase, Clyde is awed by Narron's love and devotion but swears he will return to capture Bernard. Later, after a blinding blizzard, he finds Narron—freezing and almost dead in the snow—and respectfully returns her to Bernard without arresting him.

In a romantic narrative like this, Wyeth could have chosen from many moments to create an illustration enhancing the theme of love in the story. Instead, he selected the dramatic point when Clyde discovers the half-frozen heroine. The viewer must imagine what happened before this point and what will unfold next, but the ending is not divulged. By choosing not to illustrate the outcome, Wyeth leaves more to the imagination, and the moment of suspense is heightened by visualization. As Pyle instructed, Wyeth used his skill at portraying man in nature to create a painting that works with the writing and does not steal its emotional content.

Fresh from his second trip to the American frontier, N. C. Wyeth was acutely aware of the exposure and loneliness that men experience in the wilderness. The main figure in the painting stands alone just as he discovers a body almost buried in the snow. Wyeth masterfully captured a feeling of action while faithfully portraying the awkward balance of walking in cumbersome snowshoes. The twisted posture of the tracker draws all our attention. He has pulled off his glove, and his bare hand is reaching to his gun because he is unsure about the seemingly lifeless form. A patch of distant sunlight and the bare silvery birches reinforce the chill scene. The minimal amount of color sufficed for reproduction in black and white, and Wyeth used the absence of color effectively to enhance the atmosphere of bitter cold.

V. M.

Illustration for "Love in the Wilderness" by Lawrence Mott,
The Outing Magazine, November 1906, Frontispiece.
Oil on canvas, 38 x 24", signed lower left.

Harvey Dunn
THE SEARCH PARTY

THE ACTION IS centered on the attempt of a search party to find the hidden entrance to a mine where a stranger is trapped by a rock fall that blocks the main entrance. The party is led by the central figure in the picture, who has just heard the first faint call for help. The hero, a condemned man, can save his own life by saving the stranger. Only he knows, however, that the trapped man is the one who, many years earlier, seduced and ran off with his wife, Marcile. His drive is for revenge. If he can find the man first, he will kill him.

Dunn's picture is less melodramatic than the story, and his theme is more universal, depicting the searchers in the high country and emphasizing the difficulty of the rocky, mountainous terrain. Here Dunn artfully paralleled the steep incline of the mountain with the silhouetted shapes of the men against the sky. The raised gun and the distant hawk on the left help to turn the viewer's eye back into the picture and to the hero of the tale.

This picture as it was originally published in *The Saturday Evening Post* was reduced to approximately 4 x 6 inches in a very gray reproduction. The reader would have had no idea that the original painting was six times larger and in full color.

Why did Dunn and the other students of Pyle work on so large a scale, and why did they go to the trouble of painting in color when all that effort would be unappreciated by the public?

An answer is that although the work was commissioned by book and magazine publishers, the artists were still attempting to meet Pyle's standards. Pyle believed that an illustration should be a serious work of art. He motivated his students to paint pictures that would outlive their use as published commissions.

W. R.

"I hear ver' good. He is alive."
Illustration for "Marcile" by Gilbert Parker, *The Saturday Evening Post,* January 4, 1908.
Oil on canvas, 36 x 24", signed and dated 1907, lower right.

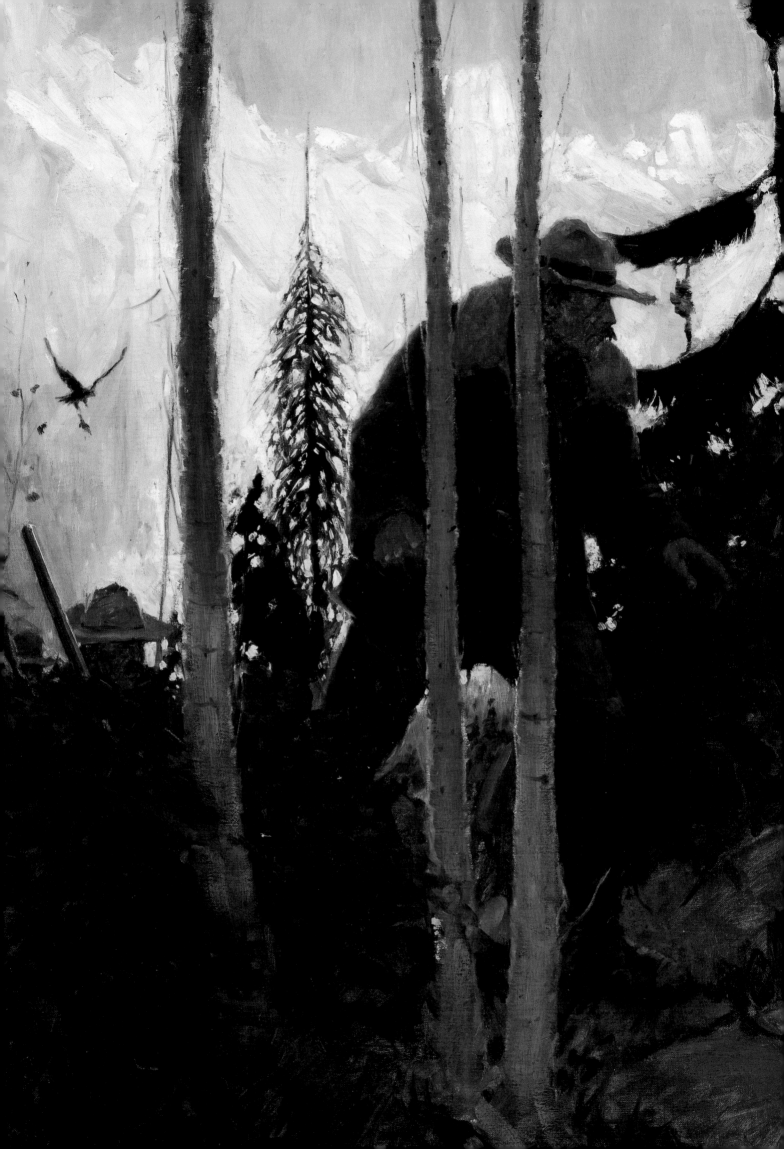

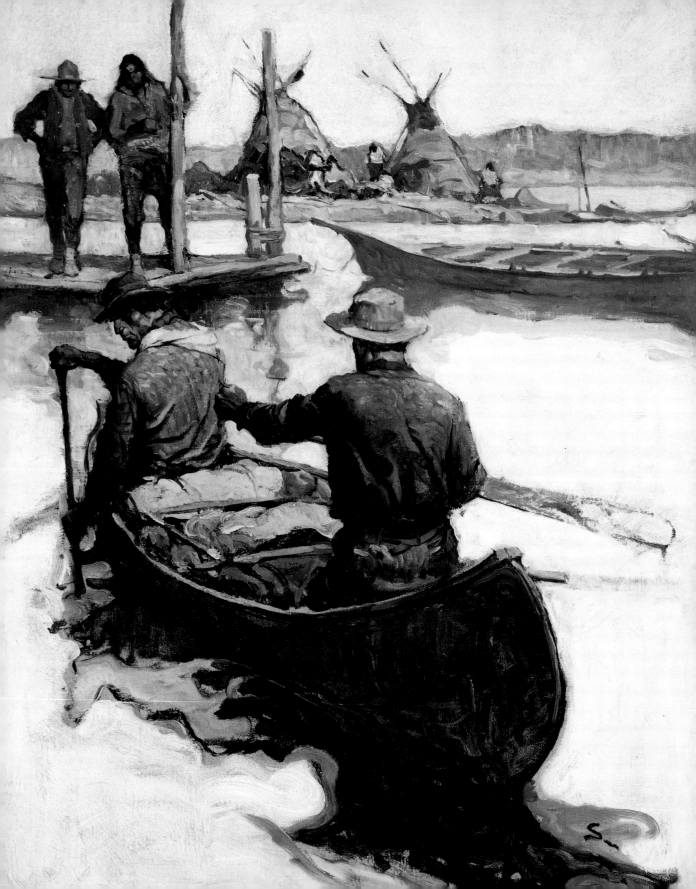

Frank E. Schoonover
APPROACHING CAMP

"APPROACHING CAMP" is a story illustration that conveys many of Schoonover's own experiences from a canoe trip he took in Canada thirteen years earlier. In the story "Valley of Voices," the reader takes a whitewater adventure through the northland streams and the remote fur trading posts of the Wailing River with Brent Steele, an explorer in the service of an American museum.

"Approaching Camp" was reproduced in *Redbook* magazine in black and white as the right-hand panel of a two-page spread. Both halves were painted separately, but they appear as one in the story. The left-hand panel shows a settlement of houses on a hill behind a crowd of Indians who have gathered on the shoreline to watch the canoe as it approaches.

Schoonover painted this illustration "vignette style," using broad brush strokes, a white surround, a less-defined background and a limited palette. The main characters are emphasized by the dark outline he painted beneath the canoe and the finer brushwork and detail in the figures. The convergent lines of the canoe and the longboat attract the viewer's eye to the two figures watching from the dock. The canoeist in front, turning to his companion, has a questioning look on his face that suits the moment of the caption.

Schoonover prided himself on how well he collaborated with many of the authors who wrote about the North Country. He was known as an authority on Canadian subjects, and he knew the northern wilderness intimately from his winter snowshoe expedition in 1903–1904.

By the spring of 1911, however, he felt a need to gather new material. He set off on another trip through Canada, this time by canoe. In a description of this journey, he wrote:

> I started north from Jackfish on the north coast of Lake Superior and canoed by the Hudson Bay
> Long Lake Post route down the Kenogami to the James Bay Country. This long canoe trip gave me
> a fine idea of the summer life of the Indians. I saw the coming of the fur brigades to the Post, the
> trading of the winter's harvest of skins, and the spending of the credit. I watched the building of the
> bark canoes and enjoyed the summer tepee life of the carefree trapper.

Schoonover did indeed return from this trip with vast resources of new knowledge and imagery for his illustration work. It was from these new experiences that he brought forth the true feeling of the Canadian outdoors in his paintings. In "Approaching Camp," Schoonover composed an authentic picture of the rugged northern frontier life by drawing from the invaluable store of sketches, photographs, and records that he kept from his journeys.

S. S.

"That a canoe should draw the population to the shore was strange. 'They may think we're a police canoe,' suggested Steele."
Illustration for "Valley of Voices" by George T. Marsh, *Redbook* magazine, 1924.
Oil on canvas, 31 x 25", signed lower right.

Philip R. Goodwin
LAUNCHING A CANOE

THE TURN OF the nineteenth century marked the ending of a great era for the professional trapper and the hunter. Previously the number and variety of wildlife seemed to be inexhaustible. Migrating passenger pigeons, which had darkened the sky, were hunted to extinction by 1914.

While ducks, geese, and other game birds still abounded, their numbers were declining and catches of fish were becoming smaller. Deer, elk, moose, and bear populations were also declining. Wolves and mountain lions carried a bounty in a purposeful effort to wipe them out as predators of domestic animals.

Hunting and fishing were also major sports. Most country boys owned a small rifle and learned to hunt rabbits, squirrels, woodchucks, and opossum. Any hunter worth his salt could augment the family larder with venison, duck, or rabbit.

Goodwin was not an enthusiastic hunter himself, but his artistic legacy was a record of the last years of unlimited fish and game. His specialty was the depiction of man in the wilderness: an unexpected confrontation with a bear and cubs, portaging a waterfall, or, as in this work, two hunters in a birch-bark canoe.

Goodwin knew his subject matter so well that he filled his compositions with convincing details, which other sportsmen recognized and enjoyed for their authenticity. Because of their popularity, his pictures were often commissioned by manufacturers of firearms for advertising in magazines or annual calendars, and he illustrated many magazine adventure stories.

Here he depicted the thrill of the chase as two hunters, having sighted a moose, are quickly launching their canoe to cut off its escape and bag a prized trophy. Goodwin does not show us the actual quarry, but the dedicated hunter viewer could conjure a target of his own choice.

The composition of the picture is straightforward. We are led into the painting by the rippled reflection in the foreground and follow along the prow of the canoe to the two men, bracketed by the crossed timbers and the stand of birch trees in the background, making them the center of interest.

W. R.

Slogan for Marlin Arms: "A Gun for the Man Who Knows."
Advertising illustration for Marlin Arms Corporation, 1907.
Oil on canvas, 29 x 15", signed lower right.

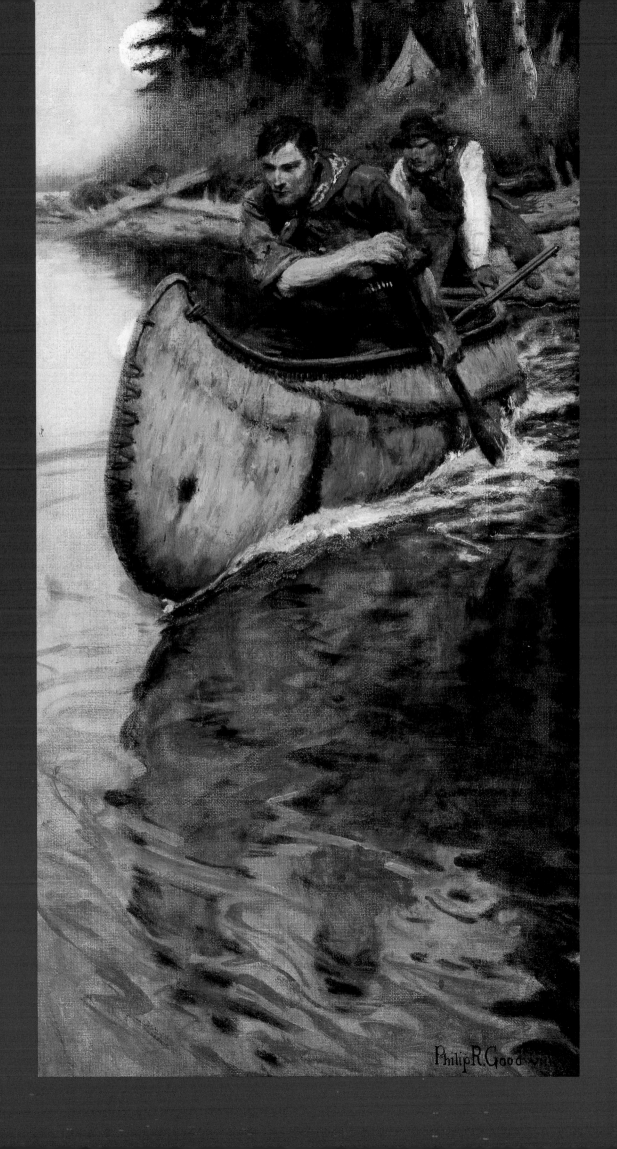

Philip R. Goodwin
SHOOTING MOUNTAIN GOATS

PHILIP GOODWIN WAS a student of Howard Pyle's who obtained national recognition as an illustrator of sportsmen. His work was principally of the outdoors, and depicted hunters and fishermen. In many of his works a viewer can see the influence of his friend and mentor Charles M. Russell, whom he had known both in New York City and later at Russell's ranch in Kalispell, Montana.

Although today Goodwin is just being rediscovered, many of the old-time sportsmen remember his wonderful Brown and Bigelow calendar subjects and the Winchester trademark of the Horse and Rider. In addition to his commercial work, he illustrated Jack London's *Call of the Wild* and *African Game Trails* for Theodore Roosevelt. Goodwin died at the early age of fifty-four, but he left an important legacy in American sporting art.

The painting "Shooting Mountain Goats" demonstrates Goodwin's feel for Western big game hunting, the region's rocky terrain, and his knowledge of the Western horse. He applied his paint with boldness and sure knowledge. His skillful drawing is evident throughout. His use of color is rich and varied, and, in a reversal of roles, the younger Goodwin played an influential part in expanding the palette of his good friend Russell by helping him to see color more impressionistically. All of these qualities, plus Goodwin's fine sense of design, transcend the visual limitations of an illustration.

M. F. & J. A.

"Shooting Mountain Goats."
Oil on canvas, 34 x 18 ",
signed and dated 1909, lower right.

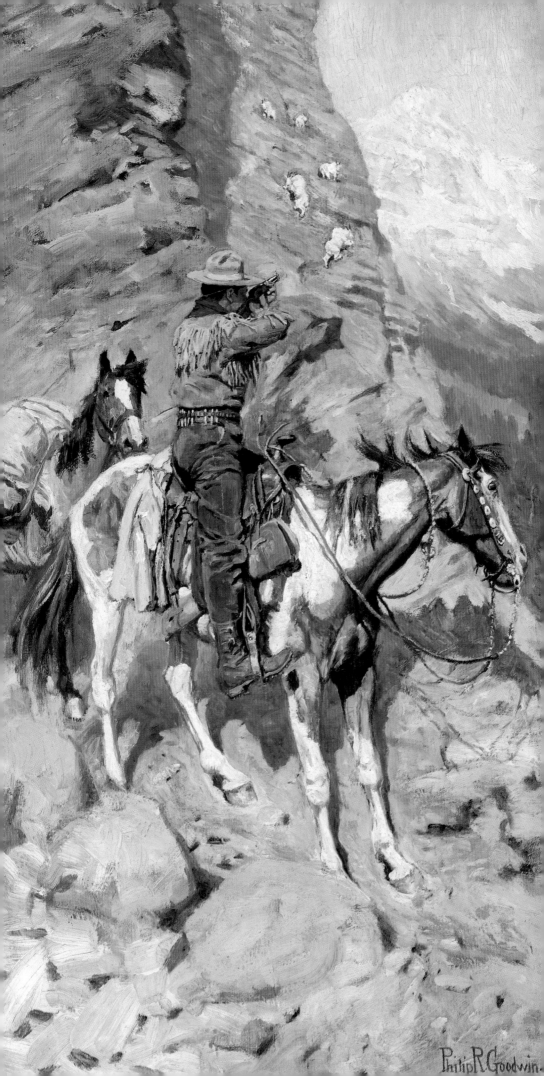

Philip R. Goodwin

Frank E. Schoonover
NORTHWEST MOUNTIE

IT WAS THE duty of the courageous Royal Canadian Mountie to keep law and order in the vast Northwestern territory. He led a dangerous and exciting existence. In this painting Schoonover portrayed the Mountie dressed in full regalia, his scarlet uniform and broad-brimmed hat symbolizing the strength and power of his office. The viewer can see that something is threatening him by his facial expression and his steady stance: he is alert, his pistol drawn, watching for potential danger.

To catch the attention of the many readers who voraciously bought and read pulp magazines, Schoonover intentionally painted this cover illustration with bold color and drama. "Northwest Mountie" is a purely graphic illustration as opposed to some of Schoonover's paintings that stand alone outside the context of illustration, such as the painting for "Only Jules Verbaux."

Schoonover's renown for illustrating life on the Western frontier of America and Canada gave him dominance of this theme among illustrators. It led him to commissions for many stories and magazine covers. Millions of readers anxiously awaited their monthly issues of magazines such as *The Century, Popular,* and *The American Boy,* which arrived with pages full of great adventure stories set in the new frontiers of the Northwest Territory. Between 1914 and 1924, Schoonover painted many of the cover illustrations for *Popular Magazine* using Canadian subjects.

A couple of earlier commissions for *The Century* to paint the fearless Mountie were for "Wilkinson's Chance," written by Lawrence Mott in 1906, and "Sentinels of Silence," written by Agnes Dean Cameron in 1909. Throughout the 1930s, Schoonover continued doing many illustrations for serials such as Laurie York Erskine's thrilling "Northwest Mounted Police Stories" for *The American Boy.*

This painting, "Northwest Mountie," is characteristic of Schoonover's later style of illustration. As American tastes changed and new types of stories were written, his approach to painting evolved as well. His illustrations continued to show heroes of the great outdoors, but the figures no longer had the power and ruggedness of his early characters. Grimacing pirates, sturdy Eskimos, and weather-beaten cowboys began to give way to the clean-cut, square-jawed Canadian Mounties.

S. S.

"Northwest Mountie."
Cover illustration for *Popular Magazine,* February 19, 1924.
Oil on canvas, 44 x 33 ½", signed lower right.

N. C. Wyeth
THE LOST VEIN

"THE LOST VEIN" painting, "Indian Lance" [also in this collection], and Schoonover's "Northwest Mountie" were made as covers to decorate "pulp" fiction. The short-lived *All-Around Magazine* was vying for space on the newsstands with other, equally lurid, action-packed, spine-tingling, two-fisted pulp magazines such as *Argosy, All-Story, War Birds, Adventure, Popular,* and far too many others. Creating impact for the audience was paramount. Covers demanded larger-than-life characters, bold shapes, and simple, vibrant colors. The silhouette alone had to convey the action of the picture so that it could be read instantly.

Wyeth did this admirably in "The Lost Vein." Regrettably, he had to jettison his beloved background in favor of clarity. He chose an image that would get the newsstand browser interested in the story and pick up the magazine. As the gist of the story is necessarily distilled in Wyeth's picture, a copy of the now-scarce magazine is not needed to grasp it; they must have lost the man as well as the vein of gold. Wyeth wove the shadows in and out of the figures, connecting them into a cohesive, graphic shape. These shadows nevertheless also function to project the figures forward, give them volume, and separate them in space.

The fact that Wyeth accepted a commission such as this after he'd already achieved success with the serious publishers suggests that he didn't want to be seen as "difficult" or too proud. Contrary to his strategy of clearing his schedule to allow himself more time for his avocational painting, he was crowding his easel with paying jobs. Supporting a growing family on freelance work was the probable impetus, although his work was evidently in steady demand from the start.

Although this work was painted ten years after his trips west, Wyeth had ridden the region's canyons, studied its people, worked with authentic gear, and generally absorbed enough of the West's flavor that he could return to those experiences for new paintings with great authority.

R. T. R.

Cover illustration for "The Lost Vein" by Edwin Bliss.
All-Around Magazine, February 1916.
Oil on canvas, 34 ¼ x 25", signed lower left.

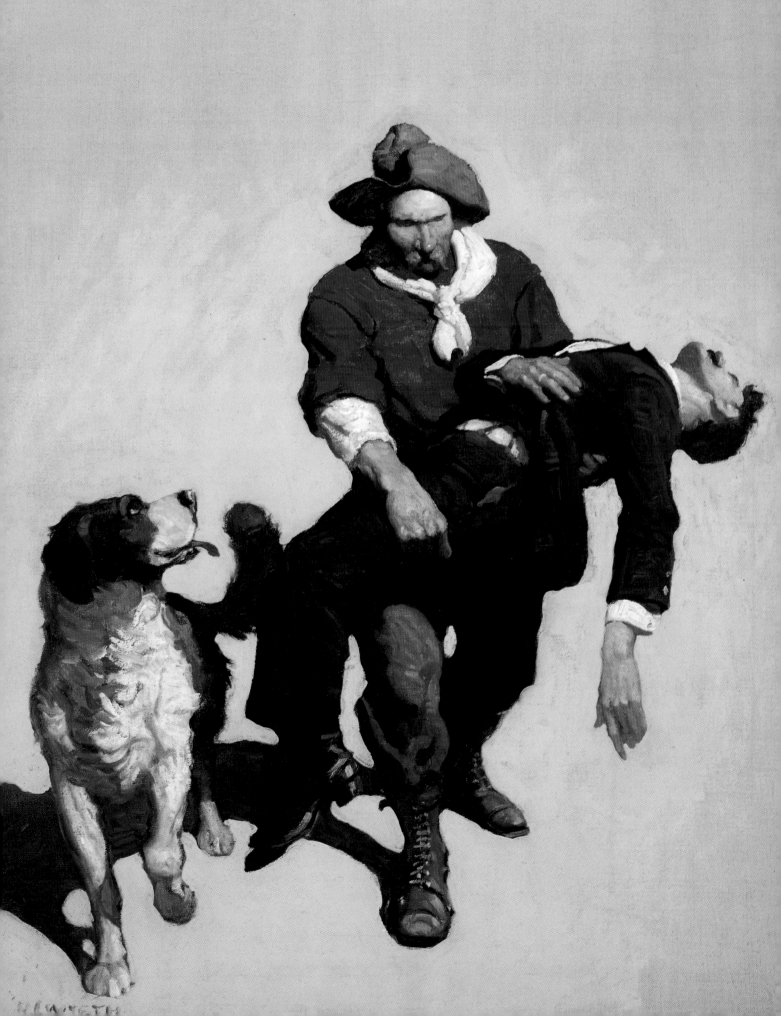

—— THE ART OF ILLUSTRATION ——
A PERSONAL JOURNEY

THE ARTISTS WHO studied under Howard Pyle were taught illustration as one of the finest arts one could aspire to. Yet N. C. Wyeth went through an extensive period of self-examination and doubt about his artistic goals and beliefs.

Thanks to the enormous professional head start he received by studying with Howard Pyle, Wyeth became, at a relatively early age, a very successful illustrator, both financially and in the acceptance of his peers. His work was published in the best magazines, and editors vied for his services. He could not even accept all the assignments that were offered to him.

Yet Wyeth soon became dissatisfied with himself and with his chosen field. He believed that he was stifling his chance for greatness by doing the bidding of editors rather than his own subject matter. In letters to his mother, he often wrote about his growing inner conflict between being an illustrator for financial reasons and exploring his artistic ambition to paint pictures of greater importance, free from commercial constraints.

He also carried on a correspondence with his fellow Pyle student and friend Sidney Chase, expanding on the same theme. It is ironic that even as he was decrying the limitations placed on him by art editors, he was being given far greater freedom than almost any other illustrator of his day. Nor was there any real impediment to his painting and exhibiting independent subjects.

Wyeth's first tentative idea had been to stop illustrating entirely and instead to support himself by being a teacher. With that idea, he contacted the art school of Eric Pape in Boston, where he had studied prior to Pyle's school. However, he soon recognized that he would only be exchanging one means of livelihood for another, lower-paying one, and would end up with no more time left for creative painting than before.

Wyeth, in fact, never did stop illustrating. He had an enlarging family to support and needed a steady income. However, he found ways to mitigate his discontent. He was often able to select those parts of a manuscript that would furnish themes for important pictures. He also began to produce independent pictures to exhibit. His first exhibited work was shown at the Pennsylvania Academy of Fine Arts in 1913, and although it was "skyed"—stuck in the top row—the exhibition had a great effect on him and helped him to put his career in better perspective.

Wyeth began to make it a regular practice to paint close to home, choosing independent subjects in the studio and landscapes of local Brandywine and Maine settings. While some of these paintings were exhibited, most were not, but these exercises had the therapeutic effect of calming his frustrations and also of recharging his artistic batteries. Wyeth continued his dual career throughout his life. His easel paintings won their share of awards, and his illustrations have given him a lasting, prominent place in American art.

W. R.

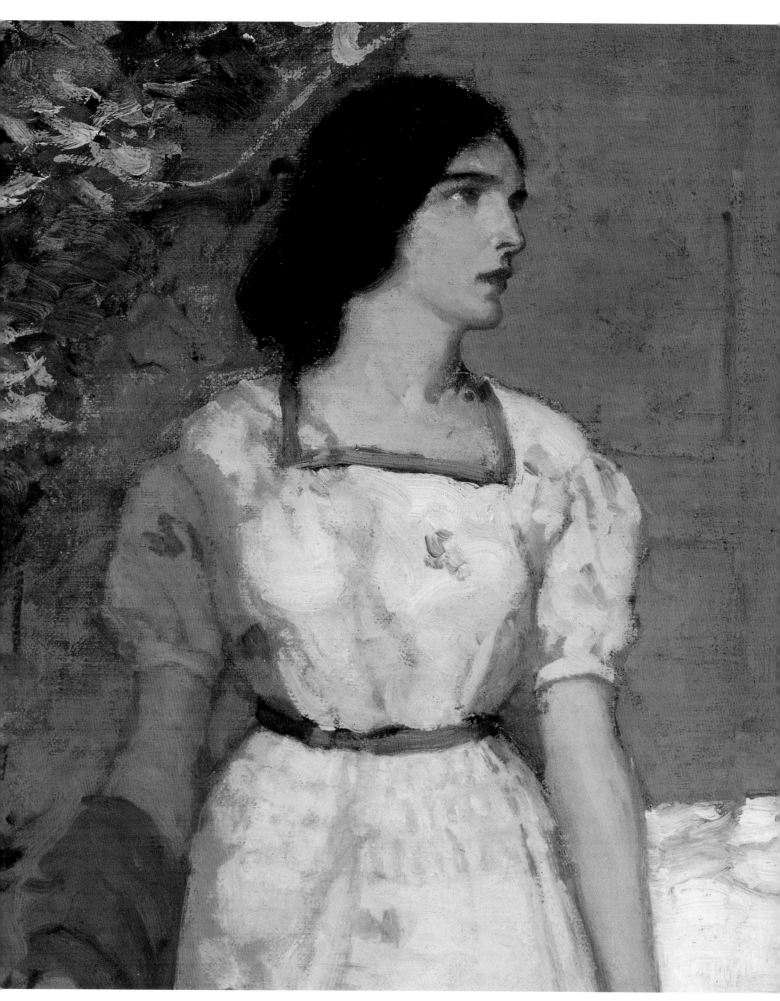

N. C. Wyeth, Detail from illustration for *Sally Castleton, Southerner,* see page 109.

N. C. Wyeth
Rip Van Winkle Awakes

Every schoolchild knows Washington Irving's tall tale of Rip Van Winkle, and Wyeth's illustrations for the book appropriately verge on whimsy without becoming farcical. In this illustration of the "punch line" or key event of the story, Wyeth introduced several reminders of sober reality to help us suspend disbelief. Subtle cues, such as the hard bright blue of the sky, with dawn violet highlights and cool shadows, show us the autumn cold snap that has set in, and Rip's pose emphasizes his struggle to emerge blearily from his comatose slumber. Wyeth has wonderfully interpreted Rip as rescuing himself from becoming *part* of the landscape.

One would think that Wyeth dreamt up such tortured, gnarly trees for just such a far-fetched and spooky story as "Rip Van Winkle." But trees similar to these do exist, indeed abound, although not in Irving's Catskills but in the Brandywine River Valley, where Wyeth could paint them from life. He found them to be excellent compositional devices, as he could indirectly point to, encircle, or various figures with their branches and trunks.

At the finale of the story, Rip is old and hung over, but he's nevertheless undefeated. He's renewed by his sleep and eager to embark on the rest of his life. In wonderment, he doesn't seem disturbed that his home is barely recognizable. The episode is an interesting commentary on journeys in general and Wyeth's in particular. The big, outward adventures in Wyeth's life were his trips out west. He had left home as a student, still dependent upon Pyle for reassurance about his work. He did not yet have a voice. In his letters he expressed varied feelings about his life and experiences in the West—pride in his ability to rope a horse, boredom with the "damned sand hills," excitement over the "hundreds of Indians." Yet by the end of the trip, he was writing back home that he felt he belonged out there.

Upon returning east, Wyeth resumed his career as an illustrator, but the landscape was now different. He received plenty of commissions for his new Western subject matter, an area in which Pyle was not active. He soon became engaged to his future wife, Carolyn Bockius, and had a quarrel with Pyle, who wanted him to work exclusively for *McClure's*, where Pyle had become the new art director. He settled into the first phase of work that was truly his own, characterized by much larger-scale canvases, monumental figures or happenings, wide-angle perspective, and a focus on one or two characters to tell the story. Within three years, he realized that he seemed "to be drawing closer and closer to the quiet 'domestic' farm life" of Chadds Ford.

At the end of the journey, every adventurer must come home. Comforting though it is to be on familiar ground, home is always changed in the process. Wyeth could draw from his own experience of this truism to give substance to Irving's theme.

R. T. R.

"On waking he found himself on the green knoll whence he had first seen the old man of the glen."
Illustration for "Rip Van Winkle" by Washington Irving, Philadelphia: David McKay, 1921, page 44.
Oil on canvas, 40 x 30", signed lower left.

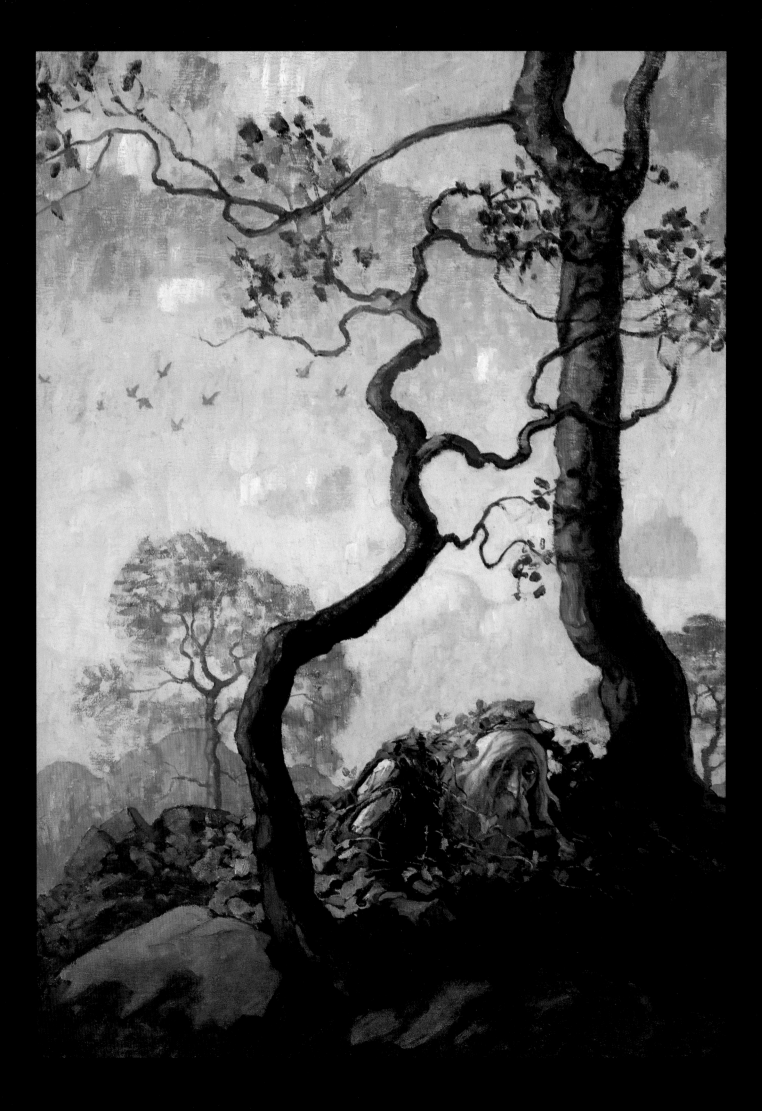

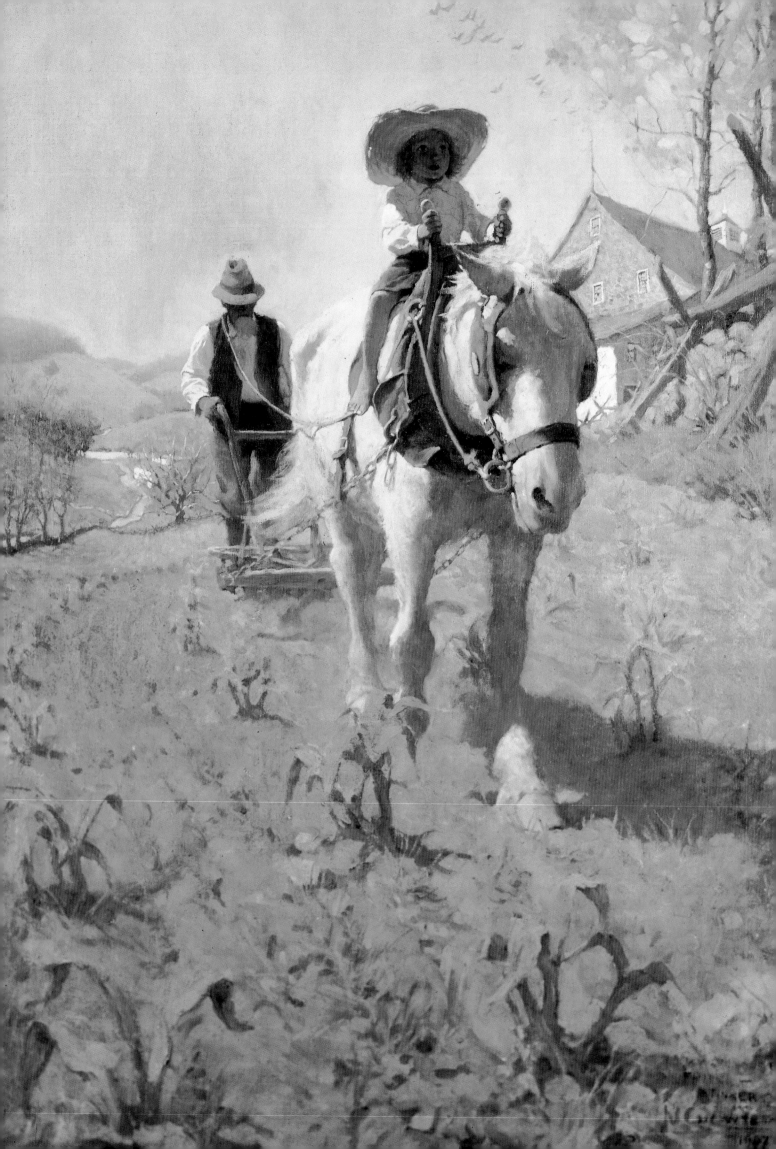

N. C. Wyeth
DOBBIN [PLOWING THE CORNFIELD]

IMPLICIT IN WYETH's quandary regarding fine art versus illustration is the question: What should a painting be about? Beneath his declarations about two warring careers lies a much closer connection between his easel work and his commercial assignments.

Although Wyeth's illustrations are ostensibly about the characters and events in their stories, his settings—mostly landscapes—are a vital part of his illustrations and often upstage the action. Part of the reason for this is that the authors of the series of stories he illustrated [*Mysterious Island, The Last of the Mohicans,* and "Rip Van Winkle," for example] were particularly eloquent in landscape description. It is evident, however, that Wyeth concentrated on this aspect of his assignments and took particular enjoyment in working out his landscapes. This is demonstrated in Wyeth's vignettes, wherein figures isolated against a blank background seem denuded, whereas his landscapes without figures are satisfyingly complete.

His most successful pictures—whether fine art or illustration—combined figures in a landscape. This painting, the illustration for a poem by Martha Gilbert Dickenson Bianchi "Back to the Farm," gave Wyeth an excellent opportunity to interpret it in a personal way, more like an easel painting complementing the text than a literal translation of it. He used the theme as a test of the critical standards he was searching for, which were playing an increasing role in his art. Later, in an article titled "For Better Illustration," published in *Scribner's* in 1919, Wyeth articulated his ideas about an artist's goals:

> The young artist . . . must sense deeply of the fact and substance of the object he is drawing; he must
> learn to love the object for its own sake, not because it is picturesque or odd, or striking, but simply
> because it is an object of form and substance revealed to him by the wonder of light that represents
> a phase of the great cosmic order of things.

Whether for exhibition or the printed page, a Wyeth painting is first recognizable by his sea foam, his dust, his grass or, particularly, his clouds. One could argue that Wyeth's landscapes carry the freight of his illustrations, and they do this not, for example, by specifying authentic foliage but by capturing the quality of light filtering through it. Thus Wyeth transcends Pyle's method of constructing a picture out of literal elements, and brings it into the realm of pure painting. So if he could successfully incorporate his fine art explorations into his illustration work, why did he find it such a strain? One could conclude that it wasn't the successes that bothered him but the challenge to make the next painting achieve the balance he sought so fervently.

R.T.R. & W.R.

"Dobbin [Plowing the Cornfield]." Illustration for "Back to the Farm" by Martha Gilbert Dickenson Bianchi,
Scribner's Magazine, August 1908. Oil on canvas, 37 x 28", signed lower right: "To My Chadds Ford friend Tinker Quimby N. C. Wyeth 1907."
Photo courtesy of Douglas Allen Jr.

N. C. Wyeth
THE SCYTHERS

THIS PAINTING FOCUSES on the figures of the scythers and provides a documentation of the era of the small family farm, when most of the work was still done by muscle power and everyone from old to young had their appointed tasks. The small girl with the crockery water pitcher is as much at the center of the picture as the two farm hands.

Wyeth was particularly influenced by the philosophy of Thoreau and he felt strongly that his paintings should be a reflection of his own personal experiences—that living and painting should be incorporated. This ran counter to the periodic necessity of illustrating articles or fiction about exotic places he had never seen and having to conjure up the facts from imagination. It made him chronically divided about his importance as an artist and created many self-doubts.

In this picture, however, Wyeth was right in his element. It is an illustration that was commissioned by *Scribner's,* but the subject of the accompanying poetry gave him the latitude to chose a personal point of view in painting it. He approached the composition as if it were a picture to be exhibited in an art gallery without any limiting concessions. There is only one line of reference in the text of the poem to Wyeth's chosen subject—"Down in the hayfield where scythes glint through the clover." Each of his paintings [there are four in the series] presents a different individual look at an aspect of farm life interpreting the spirit of "Back to the Farm." At this time in his life, Wyeth was first beginning to feel that his future career as an artist would fail or succeed depending on the seriousness of his study of nature, and he was religiously painting plein-air landscapes to add to his knowledge. Most of these paintings were never shown but they provided him with a reservoir of observations that could be integrated into his illustration commissions or other paintings.

This is an early picture, from 1908, before Wyeth had begun experimenting with impressionistic color, so it does not yet have the heightened sense of warm color in light and the cool shadows that are more characteristic of his later paintings. However, the great strength of this picture is in Wyeth's taking a humble incident and making it a universal subject. The setting was chosen from the Chadds Ford countryside and the models used are local farm lads in their typical work garb. Much of the inspiration for the picture, however, would have been drawn from Wyeth's own youth and the recollection of his own boyhood chores.

W. R.

"The Scythers." Illustration for "Back to the Farm" by Martha Gilbert Dickenson Bianchi,
Scribner's Magazine, August 1908. Oil on canvas, 37 ¼ x 26 ¼", signed lower right. University of Arizona Museum of Art,
Samuel L. Kingan Collection. Photo courtesy of Douglas Allen Jr.

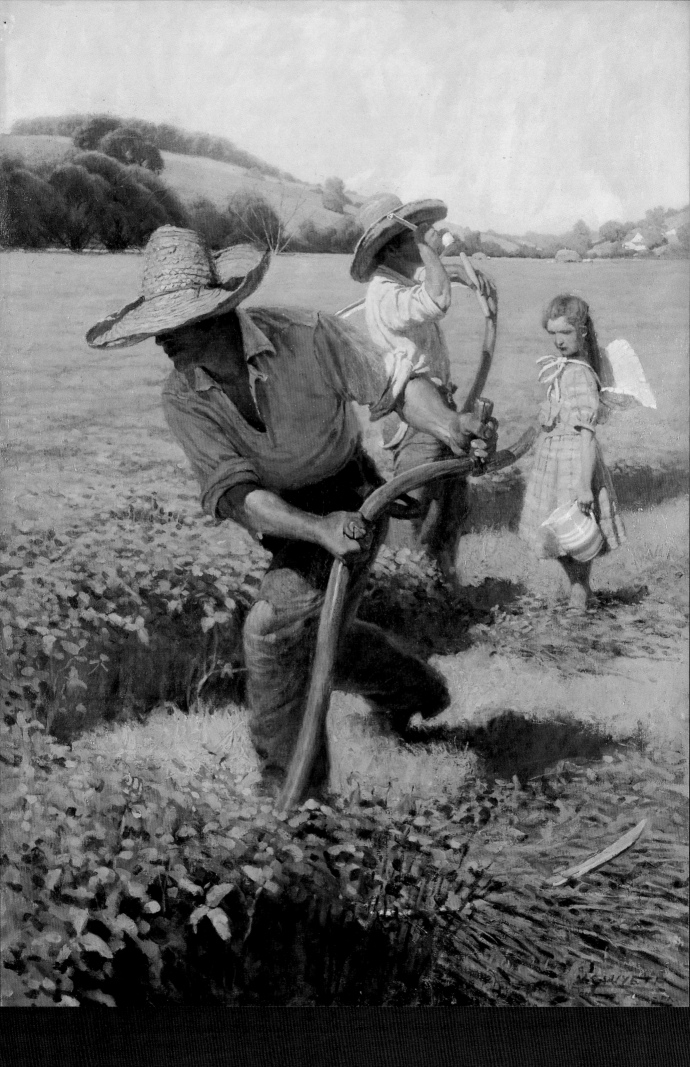

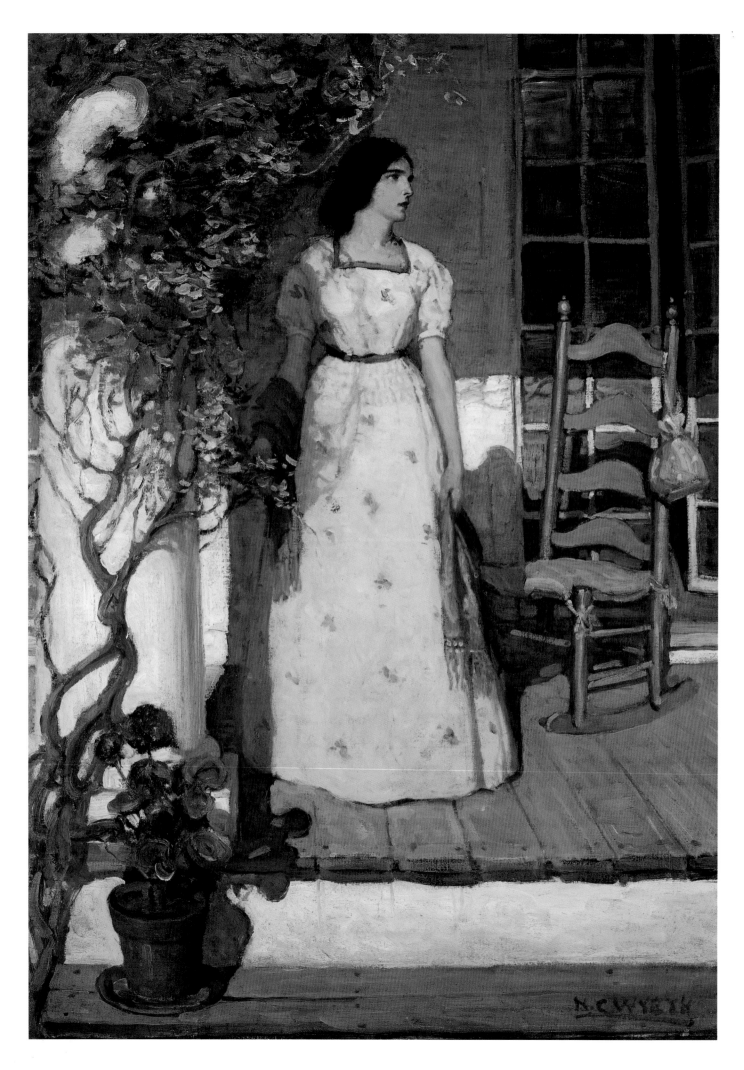

N. C. Wyeth
SALLY CASTLETON

ALTHOUGH THE SCENE ostensibly refers to the woman's preoccupation with a distant vista of a Civil War battleground, Wyeth typically chooses the scope of a sonata rather than a symphony to convey this. He gives us a spare and simple domestic scene with tenderly painted details. Because the text suggests so much more than is shown, we look for symbols and codes in the few objects he depicts; thus, the rose climber and the worn chair evoke a tranquillity made poignant by its vulnerability to the effects of war. To heighten this feeling, Wyeth treats a minor passage, the potted geranium, not as a background indication but with the full attention of a still life.

In 1912, Wyeth's life and work were coming into full bloom; he had just savored the success of his first Scribner's Classic, *Treasure Island,* and was working on *The Pike County Ballads* [Houghton Mifflin Co.], a pivotal series. He had just built his Chadds Ford homestead, and his third child, Nathaniel, was born. He probably used his wife as a model for the woman in this painting. As importantly, he was leaving behind the vestiges of the technique he had learned from Pyle [who had just died], and striking out with more robust sculptural brush strokes, breaking up color, and putting shadows in complementary color schemes.

With this painting, Wyeth's challenge is to portray the woman *thinking* about the war. He departs from the typical pretty domestic painting of a woman by a garden porch, giving the woman an attitude and expression that aren't passive or relaxed. But neither does she show her horror of the war with a ghastly expression, which would have suited the picture to the caption, but be unacceptable as a painting. Instead, he has her gazing squarely off-screen, at what is unknown and uncertain, at what we can't see. This solves his problem in a neat stroke. With that subtle, but unmistakable break in an otherwise static and cozy composition, he removes the work from the self-contained and self-explained scenes traditional to Victorian painting. The picture itself then manifests a certain anxiety, which fits its text and also befits its context as a painting from the early twentieth century.

R. T. R.

"*In imagination she could hear the rattling of drums.*"
Illustration for "Sally Castleton, Southerner" by Crittendon Marriot, *Everybody's Magazine,* XXVI, No. 6, June 1912, page 762.
Oil on canvas, 38 x 30", signed lower right. Courtesy of the Kelly Collection of American Illustration.

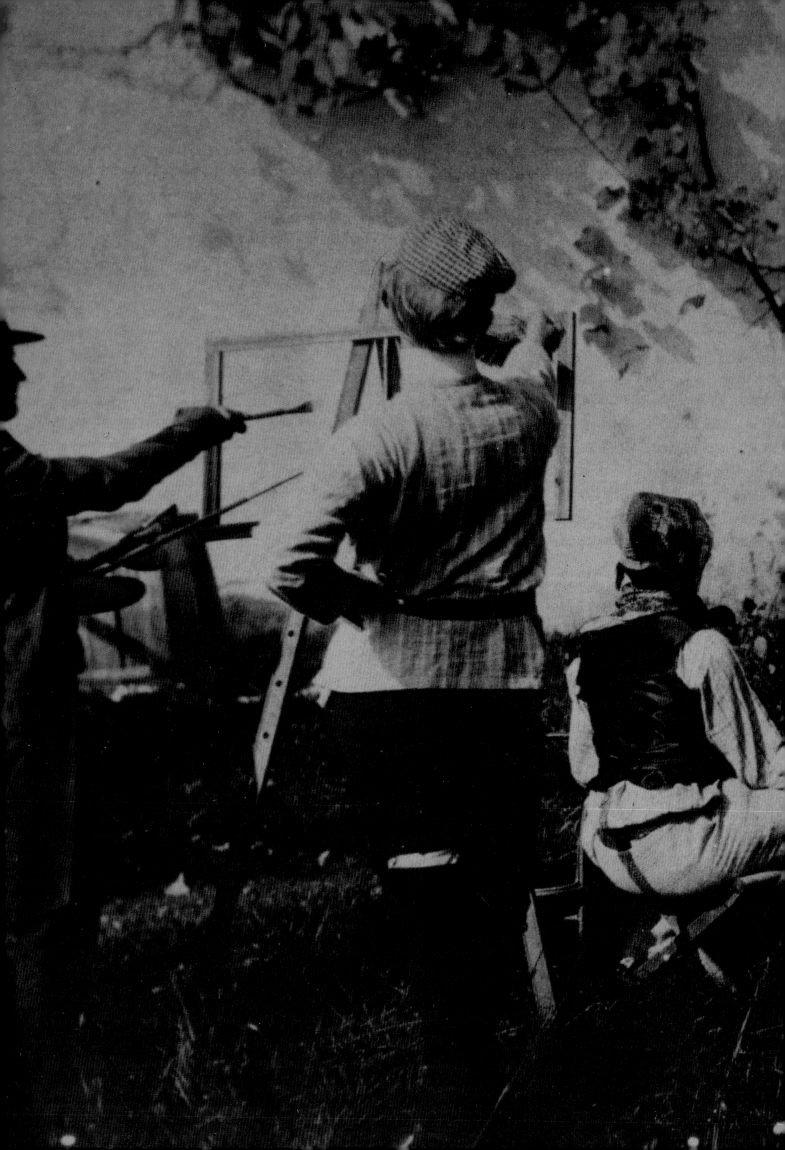

HOWARD PYLE is generally acknowledged as the "Father of American Illustration." Although he was certainly not the first, he so dominated the field during his lifetime and has had such a pervasive influence on those who followed him that he earned that pre-eminent position.

He began with some limited art instruction at a small private art school in Philadelphia and learned most of his craft as a staff illustrator for Harper & Brothers, publishers of *Harper's Weekly* and *Monthly*, *Harper's Bazaar* and *Harper's Young People*. Over the course of his affiliation there, he worked for them all. He was in stimulating company—alongside Edwin Austin Abbey, Arthur Burdett Frost, Charles S. Reinhart, and John White Alexander. He soon learned his craft well enough to break away as a freelance illustrator, establishing himself in his native Wilmington, Delaware—close enough to serve his clients in Philadelphia and New York City.

Pyle had a dual career as artist and writer. Early on he had difficulty choosing between the two, but it was his illustrated fables that led to his first employment as an artist. His interest in the Arthurian legends prompted him to write four volumes of stories, illustrated in an archaic, Dürer-like pen-and-ink style that beautifully complemented the text. These volumes and his similarly treated *The Merry Adventures of Robin Hood* won him critical and artistic acclaim in America and in England.

Although Pyle's early illustrations were limited to black-and-white reproduction by wood engraving, he surmounted these limitations with the power of his compositions. No doubt it was from his perspective as a writer that he knew the necessity of organizing his pictures to tell a story with absolute clarity. He also borrowed from the theater the strategy of staging the characters as actors and using their body gestures to convey meaning.

Much of Pyle's success lay in his selection of subject matter. Out of an entire manuscript, he chose the key substance of the story, implicit or described, and brought to it an interpretation of basic emotional appeal. His depictions of a submissive troubadour, the arrogance of high office, or the fear of mortal danger in combat are as exciting to look at as when they were first published a century ago.

Pyle's decision to teach grew out of the hundreds of requests he received from young artists and art students who admired his work. Through his students he not only established a "small school of art" but also ensured the continuance of his philosophy through their own teaching.

PAGES 110—111: Howard Pyle's students at play during an outdoor painting session. Photo courtesy of Illustration House, Inc.

RIGHT: Pyle in his studio, circa 1903. Photo courtesy of the Delaware Art Museum.

NEWELL CONVERS WYETH was born October 22, 1882, in Needham, Massachusetts. With his mother's encouragement, N. C. Wyeth attended several art schools—Mechanics Art School in Boston, Massachusetts Normal Arts School, and the Eric Pape School of Art in Boston before being accepted to Howard Pyle's School of Illustration in Wilmington, Delaware, in 1902.

After only one and a half years of Pyle's instruction, Wyeth was appearing in national magazines such as *Collier's, Harper's, Scribner's,* and others. His first published illustration of a bronco and rider appeared in February 1903 on the cover of *The Saturday Evening Post.*

With funding from publishers, in September 1904 Wyeth ventured west for the first time to explore and absorb the life of the American frontier. His disciplined observation, imagination, and vivid recall of his adventures provided him with years of material—enough to fulfill America's thirst to experience the West through words and images. He quickly became a successful and busy illustrator.

After his second trip west, Wyeth returned to Wilmington and married Carolyn Bockius on April 16, 1906. With marriage, his attention turned to the pastoral Chadds Ford countryside, a few miles from Wilmington in the heart of the Brandywine River Valley. There he purchased a house and raised his family. The rolling hills, planted fields, gentle brooks, and woodlands captivated his imagination. This softer landscape, in contrast to the rugged West, appears as the background for many of his subsequent illustrations and is the subject of many easel paintings.

While still working near Pyle, Wyeth increasingly developed his own style and reputation. His illustrations were in such demand that he was able to command top prices and select the work of his choosing. He already seemed to feel the need to grow beyond conventional illustration and paint more from his soul. Stimulated by the poetic beauty of the Brandywine landscape, he sought more work in this direction. These busy years saw the creation of some of his most serenely reflective works, such as "The Indian in His Solitude" series and "The Seasons."

In 1911 Wyeth began work on his first Scribner's Classic, Robert Louis Stevenson's *Treasure Island.* This remarkable work launched a relationship between publisher and painter that continued until the completion of Marjorie Kinnan Rawling's *The Yearling* in 1939. This famous series includes such well-loved books as *The Black Arrow, Kidnapped, The Boy's King Arthur, Robin Hood, The Last of the Mohicans,* and many others. Although Wyeth painted thousands of illustrations—for books, magazines, short stories, advertisements, and murals—and plein-air easel paintings, the often reprinted Scribner's series embodies his most famous work. He interpreted the literary mood of each "classic" and created a different painting style to accompany it, bringing to the canvas an energy unique to illustration or painting.

Wyeth at work on a landscape, Chadds Ford, Pennsylvania, 1909. Photo courtesy of Douglas Allen Jr.

N. C. Wyeth with the completed illustrations for *The Rakish Brigantine*. Photo courtesy of Douglas Allen.

His sensitivity and appreciation of children must have aided his natural ability to paint children's literature. He loved their imaginations and sought inspiration from them, retaining the spirit of childhood throughout his life. He took fatherhood seriously and raised five sons and daughters, actively participating in their development. He taught them drawing and painting, literature, music, appreciation of nature, and the power of imagination. His conscious goal was to create a truly American art and a generation of artists to fulfill it. Each of his children—Henriette, Carolyn, Nathaniel, Ann, and Andrew—became a prodigy in painting, music, or science.

In his letters N. C. Wyeth frequently refers to his commitment to truth, high ideals, and hard work through the arduous study of nature and painting. He constantly listened to classical music; Beethoven was his favorite. He read voluminous amounts of literature and philosophy. He always carefully studied a novel before committing to paint. In harmony with his great admiration for Thoreau and Emerson, he sought and found beauty in the nature around him.

N. C. Wyeth had an acutely developed ability to feel and experience every sense fully and communicate the power of his sensations through his painting. He gained inspiration from examining the minute details

of nature and the great ideas in philosophy in his quest to appreciate and respond in painting to the meaning of existence. The slightest subject could evoke a history of emotion going back generations. For example, a sprig of spruce tree from his grandfather's farm, sent every year at Christmas, suggested to him the tree, countryside, mother, home, and an entire background of feelings. He often highlighted such familiar details in his illustrations, seeking to trigger emotional responses beyond the immediate circumstances of the story.

Howard Pyle believed in the nobility of the calling to be an illustrator. But N. C. Wyeth continuously strove to create art beyond the confines of an assignment. He was enormously successful in his lifetime as a master illustrator but yearned for recognition in the world of "fine art," where he perceived that art achieved its highest ideals of truth and beauty. He frequently tried to separate himself from the time pressures of illustration in order to concentrate on his personal painting, but he continued accepting assignments, even up to his tragic accidental death in 1945.

As time went by, Wyeth did more and more easel paintings and he worked more diligently at achieving his ideal. But although these paintings are beautiful, they are only now beginning to receive the same recognition as his illustrations.

BORN INTO a homesteading family in South Dakota, Harvey Dunn began in early childhood to draw on any surface he could find, including the wall of his one-room schoolhouse. He had a frustrating period of study at the Chicago Art Institute before he was invited to study with Howard Pyle in 1904. There he found his true artistic direction.

In many ways Harvey Dunn seemed to be the antithesis of his teacher, Howard Pyle. Their backgrounds were entirely different. Pyle was from the urban East. Dunn was a product of homesteading isolation and hard physical labor. Pyle was mystical, imaginative, and a spellbinding storyteller. Dunn was pragmatic and blunt, with a powerful physique. He painted with a heavy hand, using a broad brush and gobs of paint.

Yet of all of Pyle's students, it was Dunn who was most like his master in his dedication to teaching. Like Pyle, he inspired devotion in his students and instructed a large second generation of illustrators to carry on the Pyle picture-making philosophy. And beneath that bluff facade, Dunn was poetic and could be lyrical in his concepts. Dunn first established his school with Charles

Harvey Dunn in 1951 in Littleton, Colorado. Photo courtesy of Illustration House, Inc.

Chapman in 1915 in Leonia, New Jersey. Among his best-known students were Dean Cornwell, Saul Tepper, and Harold Von Schmidt.

Robert Karoleviz explains in his book *Where the Heart Is: The Story of Harvey Dunn* that:

> In general, Harvey Dunn's classes enjoyed the reputation of post-graduate status, an inner sanctum of excellence, as it were. Like his own mentor—Howard Pyle—he taught a philosophy of life more than he taught art. He paid little or no attention to techniques, emphasizing instead the qualities that separated an artist from a draftsman. "Paint a little less of the facts and a little more of the spirit," he would say. "Paint more with feeling than with thought. . . . When intellect comes in, art goes out.

Dunn, like Pyle, made his illustrations more of a distillation of the story than a literal translation of the text. He sought the underlying universal theme of a picture, concentrating on the epic rather than the incident.

According to Mario Cooper in his book *An Evening in the Classroom*, Dunn declared in one of his classes that:

> Art is a universal language and it is so because it is the expression of the feelings of man. Any man can look at a true work of art and feel kin to it and with he who made it—for he had the same number of heartbeats a minute, comes into the world to face the same joys, sorrows, and anticipations, the same hopes and fears. A vastly different vision may arise in the consciousness at the mention of a word, but our feelings are the same. By this you may know that the Brotherhood of Man is.

W. R.

FRANK EARLE SCHOONOVER was one of Pyle's early students at Drexel Institute and in Chadds Ford, Pennsylvania. Schoonover experienced the fullest measure of Pyle's teaching and exemplified it in his pictures and in his own teaching.

As a young boy Frank Schoonover read books illustrated by Howard Pyle. He always had a sense of adventure and delighted in drawing whatever was in his imagination. He even drew from Pyle's pictures, all the while learning the intricacies of depicting a story dramatically. Later, in high school, when he learned that Drexel Institute was offering illustration classes with Howard Pyle, Schoonover saw this as an opportunity to study with the master himself! He quickly applied and was honored to be accepted, beginning his studies in 1897 and graduating in 1900. In the summers of 1898 and 1899 he received one of ten scholarships to Pyle's summer school in Chadds Ford, Pennsylvania. According to an interview with the artist's grandson, Schoonover

> had originally considered entering the ministry, but when he decided to attend Pyle's school it set him on his way to a career as an illustrator. Howard Pyle insisted on certain day-to-day disciplines for his students along with the freedom to express themselves. He told them: "You must experience, you must put yourself into the painting, or it's not believable. People won't believe you, no matter what the image." That is what made each of his students' work unique. Each painting represented the artist's own life, his soul, his own experience—not Pyle's experience.

One of Schoonover's early illustration assignments involved a story with a setting in the territory of the Hudson Bay, and Pyle encouraged him to travel there as part of his research. Schoonover spent several months in 1903–1904 living in the Canadian wilderness, bringing back enough experiences to draw upon for the rest of his career. In the process, as Pyle had foreseen, he developed his own identity as an illustrator. In 1905 he wrote and illustrated "The Edge of the Wilderness," which was the first story of his own to be published in *Scribner's*. A second story, "Breaking Trail," was published the same year.

In addition to his journeys through Canada, Schoonover traveled to Europe, the American West, and the Louisiana Bayou, continuing to find new material for his illustrations as well as his writing. In 1905 Schoonover collaborated with the author Clarence Mumford to illustrate the Western story "Bar-20," which featured the popular cowboy hero Hopalong Cassidy. In 1911 he wrote and illustrated "The Haunts of Jean Lafitte," a short pirate story set in the bayous of Louisiana, for *Harper's* magazine. Later, in 1918, he was commissioned to do a series of World War I paintings for *Ladies Home Journal*.

Frank Schoonover's grandson says of early visits to his grandfather's studio on Rodney Street in Wilmington, that it was

> like a great museum; even in the 1960s it was chock-full of his entire life's output. Especially since he always insisted that his paintings be returned from the publishers. Not many illustrators did that. Their work was created, approved, and sent off to be used for publication and seldom returned. Although that happened to a few of my grandfather's works, the bulk of his paintings came back to him. He had an active artistic career until he was almost ninety years old, and memorabilia from his life as an artist, illustrator, photographer, cartographer, muralist, and stained-glass designer were kept everywhere in his studio. Keeping track of things was just a part of his personality; he kept detailed records of his work and also kept a daily diary. In his daybooks, he recorded doing over 2,500 paintings and illustrations in his lifetime.

LEFT: Frank Schoonover in his studio. RIGHT: Schoonover at James Bay in 1903. Photos courtesy of John Schoonover.

Frank Schoonover illustrated over a hundred classic children's books in the 1920s for Harper & Brothers, including *Robinson Crusoe, Kidnapped, Gulliver's Travels, Swiss Family Robinson,* and *Grimm's Fairy Tales,* as well as a series of historical books written by Lucy Foster Madison, such as *Lincoln, Lafayette,* and *Joan of Arc.* He illustrated and wrote many articles and stories for *Scribner's, McClure's, The Century, Outdoors, The American Boy,* and many other magazines.

Schoonover was instrumental in the establishment of the Wilmington Society of Fine Arts, of which he was lifetime director and the coordinator of many exhibitions. Acting as chairman of the society's fundraising committee, he helped to procure one of the greatest collections of Howard Pyle's work, as well as the Bancroft Collection of Pre-Raphaelite paintings. Schoonover was also one of the organizers of the Wilmington Sketch Club in Wilmington, Delaware. He was affiliated with the Salmagundi Club and the Society of Illustrators in New York as well as the Philadelphia Art Alliance and the Philadelphia Academy of Fine Arts.

In 1962 the Wilmington Society of Fine Arts [now the Delaware Art Museum] held a one-man retrospective exhibition of Schoonover's paintings. His illustrated books and the Frank E. Schoonover Archives are now at the Delaware Art Museum and library. His paintings are also represented in the permanent collections of the Brandywine River Museum in Chadds Ford, Pennsylvania, which holds a complete collection of his illustrated books, and the Glenbow-Alberta Institute in Calgary, Canada.

From 1942 on, Frank Schoonover ran his own art school in his Rodney Street studio in Wilmington, which his grandson restored in 1984, passing on the knowledge of painting that he learned from his teacher, Howard Pyle, and following his own credo: "Imagination is the key to reality."

S. S.

Philip R. Goodwin in wilderness garb. Photo courtesy of Douglas Allen Jr.

CONNECTICUT-BORN Philip Russell Goodwin was a descendant of Governor William Bradford of the Plymouth Colony. After studying at the Rhode Island School of Design and at the Art Students League, he attended classes with Howard Pyle at the Drexel Institute in Philadelphia in 1900.

Goodwin was always interested in animals, particularly wild animals, and in hunting and fishing. On his own he carefully worked out diagrams of the skeletons and muscles of various animals to better understand how their anatomy affected their movement. Since Pyle encouraged his students to follow their own proclivities, Goodwin painted wildlife and landscapes, particularly the out-of-doors, to better understand color. His use of color developed into one of his greatest picture-making strengths.

When Pyle was convinced that Goodwin was ready, he arranged for Harper & Brothers to let him illustrate the manuscript of a novel by Robert W. Chambers entitled *Cardigan*, a project Goodwin shared with Frank Schoonover. Another early book-illustration assignment, when he was only twenty-two, was for Jack London's famous *The Call of the Wild*. This was done jointly with the eminent animal artist Charles Livingston Bull. The great success of that book earned Goodwin a national reputation as a wildlife artist and won him London's friendship.

His career under way, Goodwin began to receive commissions for covers of various sporting magazines and calendars. Scribner's published a special portfolio of his paintings, and he was commissioned by Theodore Roosevelt to illustrate his book *African Game Trails*.

Goodwin became friends with most of the authors of the books he illustrated, as well as with the other artists active in his specialty—Carl Rungius, J. N. Marchand, Ernest Seton-Thompson, and, especially, Charles Russell. They had met in New York when Russell was trying to get a toehold as an illustrator. Goodwin, although several years Russell's junior, was able to introduce Russell to the right people and to other artists, and they became lifelong friends. Many of the illustrated letters they wrote to each other over the years are still in existence. Several of Russell's letters to Goodwin are included in the published books, *Good Medicine* and *Paper Talk*, now combined in the recently published *Charles M. Russell, Word Painter*.

Goodwin's greatest assistance to Russell was teaching him how to use color and light in his paintings when they painted landscapes together. Russell's work changed dramatically after this experience—influenced, through Goodwin, by Pyle.

Goodwin's work was always distinguished by careful observation and realism, whether for stories in *Scribner's, Harper's,* and *The Outing,* or for advertisers such as Marlin Firearms and Winchester Arms. Many of his calendar paintings for Brown & Bigelow pictured the thrill or frustration of hunters in the wilderness—a surprise encounter with a moose, a bear with cubs invading a campsite, a hunter's prudent retreat from a skunk. He could empathize with animals as well as with humans. Friends in an adjoining studio reported hearing him growl ferociously to get into the right mood to paint a grizzly bear. His animals always look convincing, and his pictures are particularly satisfying to sportsmen, who recognize the accuracy in his detail.

Many of Goodwin's pictures are held in museum collections, including the Brandywine River Museum, the Delaware Art Museum, the Amon Carter Museum in Fort Worth, Texas, and the Glenbow Museum in Calgary, Alberta, Canada, which houses a large collection.

W. R.

DEAN CORNWELL IS on the short list of greatest illustrators of the twentieth century, although for most of his career his work can be considered a distillation of the work of others. Cornwell was born in Louisville, Kentucky, and had a background as a newspaper artist in Chicago before moving to New York to study at the Art Students League. After three months he learned about Harvey Dunn's school and quickly enrolled. He was Harvey Dunn's earliest and most successful student and thereby considered himself a "grand-pupil" of Howard Pyle.

He made a spectacular entrance on the magazine scene with his strong, impressionistic paintings for stories in *Redbook* magazine, beginning in 1915.

Throughout his career, Dean Cornwell adhered to the Brandywine principles of illustration. He gave life to his pictures by selecting the key moments of the story, composing the figures and scenery to contribute to the narrative, elucidating the character of each player, and researching his costumes and accoutrements with diligence. Cornwell's people are always real individuals; clearly he took care in selecting the models to suit the story.

It was composition and color, however, that were paramount to Cornwell, and following the sequence of his paintings during his primary period of magazine story illustration [1918–1925], one can see how he involved himself in each picture by finding a formal device [such as a patterned dress, a scarlet hue, an oval mirror frame, etc.] upon which to build.

At the beginning of this period, in addition to following Dunn's principles, he imitated Dunn's style shamelessly. There are a few paintings for which it is hard to tell at first if Cornwell or Dunn was the artist. Cornwell also seems to have set himself up to compete with the master, and his work by 1920 was superior to Dunn's with respect to color and refinement: he was more deliberate in his placement of detail and in capturing the quality of light.

Cornwell's careful planning and deliberation made his paintings sophisticated and appealing. But this didn't always make his paintings better than Dunn's. In Dunn's more spontaneous work, the happily "accidental" stroke can be breathtakingly perfect. In comparing the two careers, Dunn has to be considered the better colorist—but he had only begun mastering color by the 1920s.

In the 1930s, in order to leave a legacy of work that wouldn't be forgotten with the next issue of a periodical, Cornwell turned to mural painting, exploiting the approach of Frank Brangwyn. Although he never made much money on these commissions, he was regarded as the first choice for monumental public works. Among his major murals were those for the reading room of the Los Angeles Public Library, the Davidson County Courthouse in Nashville, Tennessee, and the Eastern Airlines mural in Rockefeller Center, New York. His inventive montaging and incisive draftsmanship set his work above that of the WPA artists.

Since most people have never seen his murals [for example, one is in a bank in Lewiston, Maine], it is mainly his periodical work that is better remembered today, due to collectors of magazines, books, and paintings.

R. T. R.

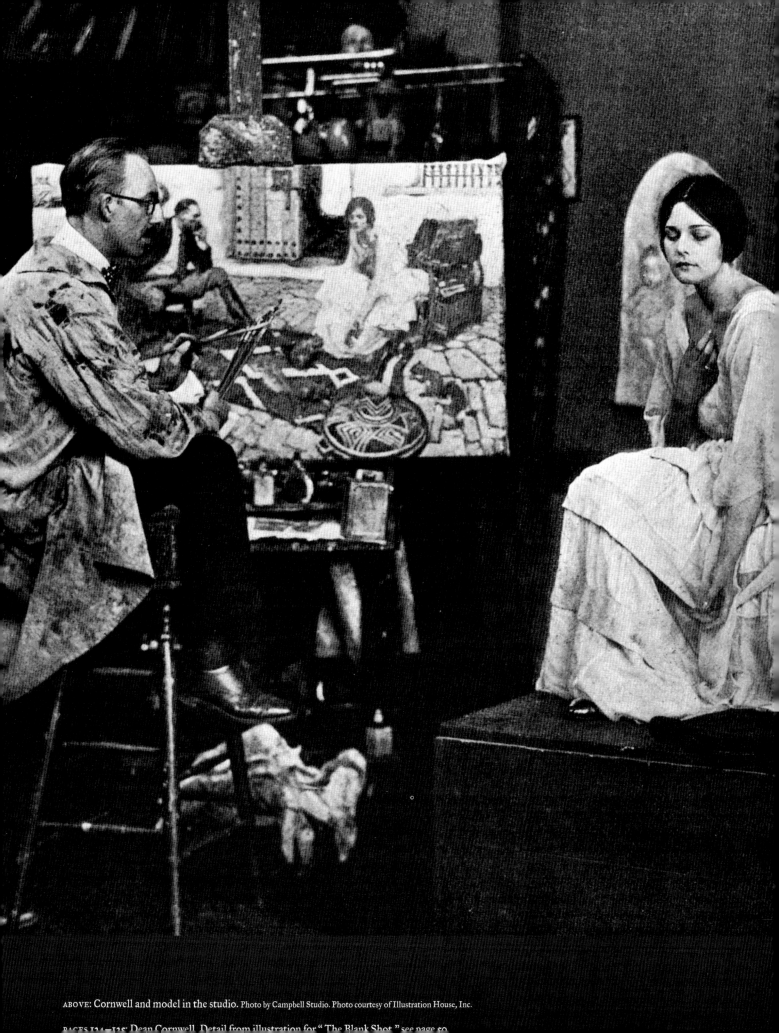

ABOVE: Cornwell and model in the studio. Photo by Campbell Studio. Photo courtesy of Illustration House, Inc.

PAGES 124–125: Dean Cornwell. Detail from illustration for "The Blank Shot," see page 50.

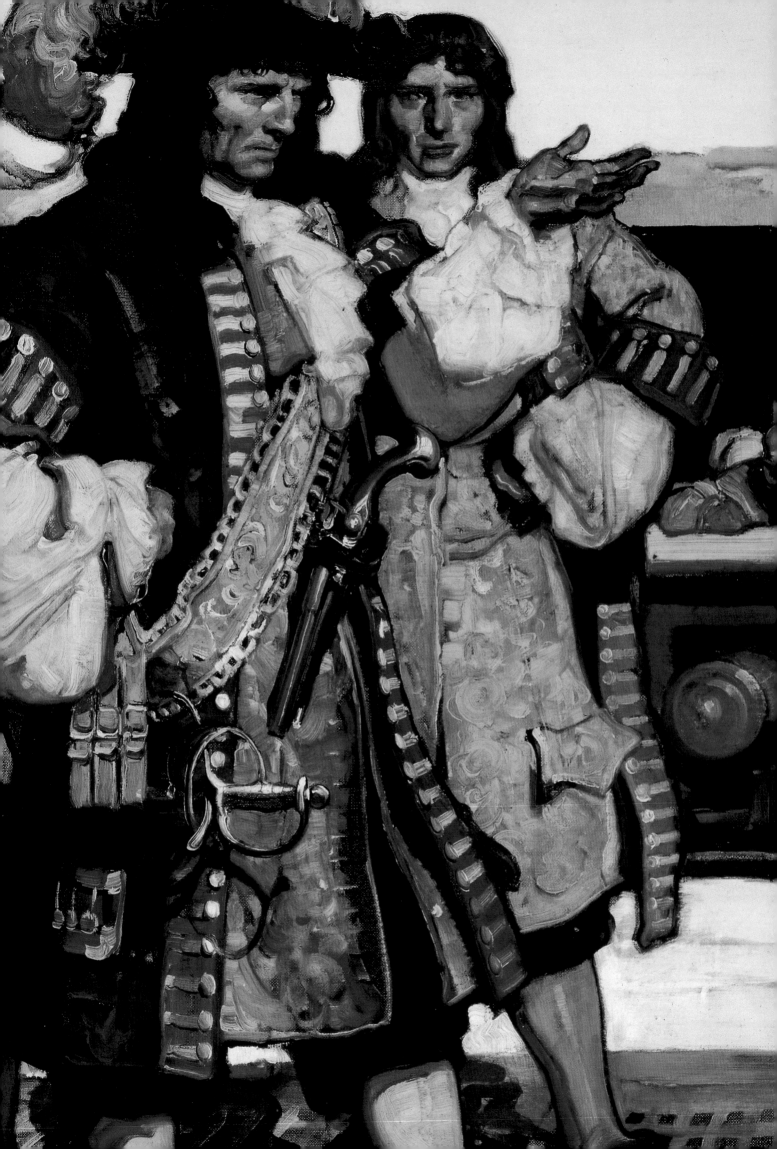

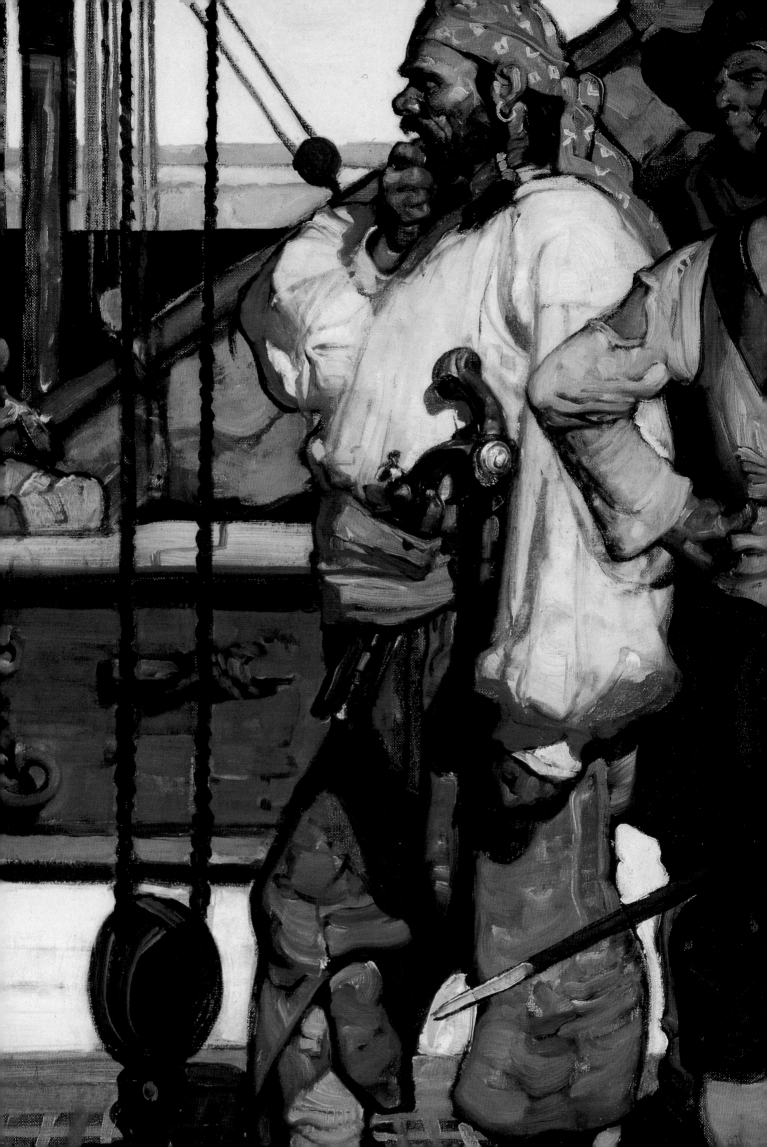

Afterword and Acknowledgments

THESE "VISIONS OF ADVENTURE" evoke the same thoughts, fantasies, and flights of escape to make-believe worlds that they did for me as a daydreaming boy many years ago. This collection is not necessarily exclusive nor does it pretend to be all-inclusive, but it represents some of the finest work of America's very best illustrators that I have been able to acquire.

N. C. Wyeth and Howard Pyle were giants; Frank Schoonover, Harvey Dunn, Philip Goodwin, Dean Cornwell, and a host of others were true masters of their craft. These are the men who dominated the field of published illustration. They created fantasies for us to enjoy and relive at a time in our lives and history when a picture was truly worth a thousand words. In the first half of the twentieth century there were no video games, VCRs, or TV sets. Much of our visual understanding of history and the outside world beyond our communities came from black-and-white photos, hand-printed re-creations, and imaginative illustrations. The fictional illustrations of the children's classics as well as periodicals and adventure novels told us so much of the stories through the size and shape of the trees, the bows and arrows, the swords, the clothes and hats that the heroes and villains carried and wore. These great artists gave us the body language, musculature, and faces that not only brought visual life and meaning to the characters, but also emphasized the responses of fear, courage, and compassion of millions of readers. These artists helped to create the literary reality of pirates, Indians, Robin Hoods, and knights.

In the fifty years preceding the proliferation of television, illustrated fiction was consumed voraciously. Instead of merely looking at pictures to enhance a plot, readers used the stories to bring the pictures into focus. Although it rarely pays to judge a book by its cover, if N. C. Wyeth or Howard Pyle had an illustration on the jacket, readers always knew a world of adventure lay inside. Advances in modern technology, new media, and educational trends have bypassed the golden age of illustration art, and it will never again be exactly the same. However, the legacy of these artists will grow in value as we realize their contribution to shaping our cultural consciousness and our history.

Studying these images and living with them has rewarded me with a deep appreciation for what these artists did to inspire our fantasies and add depth and clarity to the daydreams that many of us have. I hope that the paintings from this collection will awaken in the reader some of the same fond memories and imaginings that they have in me and in so many others. It is my hope that in publishing this book, I can share the joys of ownership that I have experienced while I had this collection and explored the intentions of their creators and the impact of their work. I am fortunate that the effort of producing this book and sharing these works has been undertaken by experts who have graced these pages with written contributions to enrich our intellectual understanding. I shall always be thankful to the following people for their help, friendship, expertise, insights, and enthusiasm: Walt Reed, editor, and Roger Reed from Illustration House; Vickie Manning and Sadie Somerville from the Somerville Manning Gallery; and Michael Frost and John Apgar of the Bartfield Art Galleries. I am also deeply pleased to thank the noted wildlife artist Douglas Allen Jr., for his insights as senior editorial consultant; Chris Fauver, for his incisive essays reflecting on the artistic merits of the paintings; and Elizabeth Hawkes, curator emeritus of the Delaware Art Museum, for her thoughtful introduction.

For their efforts in managing and shaping this project, I especially thank my wife, Laura, and my brother David, with whom I shared all of these childhood adventures and without whom this project could not have been brought together.

All of our efforts were cordially supported by Steve Bruni, executive director of the Delaware Art Museum, and his staff. We are also grateful for the many courtesies extended by Froelich Weymouth, chairman of the Brandywine River Museum, as well as by director James Duff, and the staff of the Brandywine River Museum. Mr. John Schoonover, grandson of the artist Frank Schoonover, gave generously of his time and recollections, and the members of the Wyeth family were especially helpful to Vickie Manning in her research and writing.

This book is dedicated to my father and mother, who inspired me to use my imagination and explore my horizons, and to my brothers, David, Bob, Jim, and Mike, who shared so many of my adventures and acted out so many imaginary tales as Indians, knights, pirates, and Robin Hoods. I recall, too, all my boyhood friends back in Orangeburg, New York, before suburban development transformed our small country town with one drugstore, one department store, a post office, and a hundred or so homes. The artists in this book set so many stages that we played upon as children acting out our storybook roles. We re-created endless adventures in gullies and culverts, trees, ponds and fields, rubble heaps, abandoned homes, and along the railroad tracks that led to nowhere. We made our own bows and arrows and swords, fought with staffs, built forts, and jousted on our bikes. I always had something to do—some new game to play or some crusade to launch. We had as models the adventures and scenes from stories we had been told or books we had read.

It is this special love of independence and adventure that I want handed down to my children, Laurel, John, and Mike. Finally, I hope to turn these visions of the past into adventurous dreams of the future that I look forward to sharing with Laura, my wife.

JOHN EDWARD DELL

Contributors

Douglas Allen Jr. is a painter of game animals and landscapes who studied under W. J. Aylward [Howard Pyle's pupil] and Paul Bransom. He has illustrated numerous articles for periodicals such as *Outdoor Life* and *Sports Afield* and has illustrated thirty-five books. His paintings are represented in the National Wildlife Art Museum and the Glenbow Museum in Alberta, Canada, among others. In 1972, he co-authored with his father a definitive book, *N. C. Wyeth: The Collected Paintings, Illustrations, and Murals.* In addition, he has written articles on contemporary artists for such magazines as *Sports Afield* and *Step-by-Step Graphics.* Since 1960 Allen has been a member of the Society of Animal Artists and serves on its executive board.

John F. Apgar is director of the J. N. Bartfield Art Galleries in New York City. He is a former editor of the *New Jersey Westerners* magazine and has written numerous art criticisms as well as the first book on the Brandywine artist Frank E. Schoonover titled *Frank E. Schoonover, Painter-Illustrator: A Bibliography* in 1969.

Chris Fauver is a painter who, though a dedicated fine artist, worked for years as a professional illustrator and developed a keen sympathy for the particular career concerns of the artists represented in this volume. For the last six years he has been employed by a Virginia philanthropist to select and purchase pieces that will form the core of a public collection dedicated to the work of American illustrators.

Michael Frost is a partner in the J. N. Bartfield Art Galleries in New York City. His field of expertise is nineteenth- and twentieth-century American, Western, and sporting art. Mr. Frost has lectured extensively on American Western paintings and sculpture, and is considered one of the leading specialists in the field.

Elizabeth H. Hawkes works as an independent curator in the field of American art. She served as associate curator at the Delaware Art Museum and as curator of the museum's John Sloan Collection. She organized a major Howard Pyle exhibition and was co-curator of *John Sloan, Spectator of Life.* She has written numerous articles about American illustration and is a frequent lecturer. Her most recent publication is *John Sloan's Book and Magazine Illustrations.*

Victoria L. Manning is co-owner of the Somerville Manning Gallery in Greenville, Delaware. The gallery specializes in N. C. Wyeth paintings as well as paintings from the Wyeth family, Brandywine School illustrators, and contemporary painting and sculpture. She has directed art galleries since 1977. She would like to thank Carolyn Wyeth for teaching her about the paintings and life of N. C. Wyeth and for the long talks about him that they shared.

Walt Reed and Roger Reed. In 1974, Walt Reed pioneered the illustration art market by opening Illustration House, Inc., now a gallery in New York City. His son Roger joined him in 1981. Their focus is on the history of the field over the past hundred years, and in addition to holding exhibitions and auctions, they are authors of *The Illustrator in America 1880–1980.*

Walt studied at Pratt Institute in Brooklyn, New York, and at the Phoenix Art Institute in New York City. Following a freelance career as a book illustrator, he taught at the Famous Artists Schools in Westport, Connecticut; became editor for North Light Publications; and authored several books, including *Harold Von Schmidt Draws and Paints the Old West,* which won the Western Heritage Wrangler Award for Outstanding Western Art book from the National Cowboy Hall of Fame and Western Heritage Center in 1972. His other books have included *John Clymer: An Artist's Rendezvous with the Frontier West, The Magic Pen of Joseph Clement Coll,* and, most recently, with Don Hedgepeth, *The Art of Tom Lovell—An Invitation to History.* Walt also designed the Bicentennial 50 State Flag stamps for the U. S. Postal Service in 1976.

Roger is the director and manager of Illustration House, Inc. In addition to articles written for *Antique Market Report* and *Step-by-Step Graphics* [a series on the "Masters of the Past," with Walt], Roger is preparing a bibliography of the work of J. C. Leyendecker. He is on the Permanent Collection Committee of the Society of Illustrators in New York, and has consulted for the Norman Rockwell Museum in Stockbridge, Massachusetts, and other museums in matters of authentication of the works of illustrators. Roger is the architect of the semi-annual auction sales held at the gallery.

Sadie Somerville is a partner in the Somerville Manning Gallery in Greenville, Delaware, which she founded in 1981. The gallery specializes in late nineteenth- and twentieth-century paintings and Brandywine School illustrators, as well as contemporary works by regional and nationally known artists. In addition to the gallery, Ms. Somerville has forged long-standing ties to the art community. These commitments include acting as chair of fund-raisers for non-profit arts organizations, organizing annual art exhibitions, and researching and maintaining archives for the turn-of-the-century Delaware community where she currently resides.

Selected Bibliography

Abbott, Charles D. *Howard Pyle, A Chronicle*. New York: Harper & Brothers, 1925.

Allen, Douglas, and Douglas Allen, Jr. *N. C. Wyeth: The Collected Paintings, Illustrations, and Murals*. New York: Crown Publishers, 1972.

Brown, Ann Barton. *Frank E. Schoonover, Illustrator*. Chadds Ford, Pennsylvania: Brandywine River Museum, 1971.

Chapin, Joseph. *Artist, Art Director, Friend*. New York: Charles Scribner's Sons, 1939.

Dunn, Harvey. *An Evening in the Classroom*. Privately printed at the instigation of Mario Cooper, 1934.

Elzea, Rowland. *Howard Pyle: Diversity in Depth*. Wilmington, Delaware: Delaware Art Museum, 1973.

Elzea, Rowland, and Elizabeth H. Hawkes, eds. *A Small School of Art: The Students of Howard Pyle*. Wilmington, Delaware: Delaware Art Museum, 1980.

——————. *Howard Pyle: The Artist and His Legacy*. Wilmington, Delaware: Delaware Art Museum, 1987.

Jackman, Rilla Evelyn. *American Arts*. New York: Rand McNally & Company, 1928.

Johnson, Merle, comp. *Howard Pyle's Book of Pirates*. New York: Harper & Brothers, 1921.

Johnson, Merle, comp. *Howard Pyle's Book of the American Spirit*. New York: Harper & Brothers, 1923.

Karolevitz, Robert F. *The Prairie Is My Garden—The Story of Harvey Dunn*. Aberdeen, South Dakota: North Plains Press, 1969.

——————. *Where Your Heart Is: The Story of Harvey Dunn, Artist*. Aberdeen, South Dakota: North Plains Press, 1970.

Morse, Willard S., and Gertrude Brincklé, comp. *Howard Pyle: A Record of His Illustrations and Writings*. Wilmington, Delaware: Wilmington Society of the Fine Arts, 1921.

Pitz, Henry C. *The Brandywine Tradition*. Boston: Houghton Mifflin, 1969.

——————. *Howard Pyle*. New York: Clarkson N. Potter, 1975.

Reed, Walt and Roger Reed. *The Illustrator in America 1880–1980, A Century of Illustration*. New York: Society of Illustrators and Madison Square Press, 1984.

Schoonover, Cortlandt. *Frank Schoonover, Illustrator of the North American Frontier*. New York: Watson-Guptill Publications, 1976.

Schoonover, Frank. *The Edge of the Wilderness: A Portrait of the Canadian North*. Edited by Cortlandt Schoonover. Secaucus, New Jersey: Derbibooks, Inc., 1974.

Schoonover, Frank. Diary and Frank E. Schoonover Collection. Delaware Art Museum and Helen Furr Sloan Library, Wilmington, Delaware.

Tepper, Saul. *Harvey Dunn*. New York: Society of Illustrators, 1983.

Wyeth, Betsy James, ed. *The Wyeths: The Letters of N. C. Wyeth, 1901–1945*. Boston: Gambit, 1971.